IMAGES
of America

HENRY RIVER
MILL VILLAGE

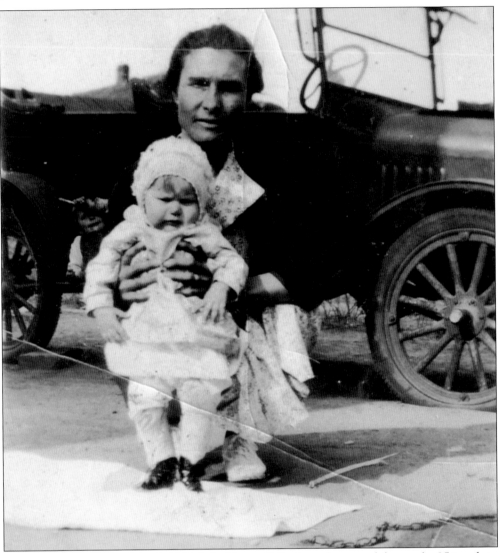

Born in house No. 4 on May 5, 1933, Ruby Young Keller's mother sewed dresses for 25¢ each to pay for her birth. In total, her mother made 20 dresses to pay the $5 fee to the midwife. Here, Ruby is held by her aunt, Mandy Young Lynn. Ruby grew up on the hill but moved one mile away at the age of 16. Now retired, she collects antique glassware and writes books. (Courtesy of Ruby Keller.)

ON THE COVER: Thought to have been taken around 1911, this image captures the faces of those who worked at Henry River Mill in its earliest days. In the beginning, the mill had about 100 employees, including children as young as nine years old. Originally operating on 4,000 spindles, the Henry River Manufacturing Company manufactured fine cotton yarns. This number increased to 12,000 before the mill came to a sputtering halt in the early 1970s. (Courtesy of Joel and Anne Aderholdt Reece.)

IMAGES
of America

HENRY RIVER MILL VILLAGE

Nicole Callihan and Ruby Young Keller

ARCADIA
PUBLISHING

Published by Arcadia Publishing
Charleston, South Carolina

Printed in the United States of America

Library of Congress Control Number: 2011944677

For all general information, please contact Arcadia Publishing:
Telephone 843-853-2070
Fax 843-853-0044
E-mail sales@arcadiapublishing.com
For customer service and orders:
Toll-Free 1-888-313-2665

Visit us on the Internet at www.arcadiapublishing.com

To my father, Richard Hefner, in memory of his mother, Maxine Newton

—NC

To the people who lived, worked, and died in Henry River

—RYK

CONTENTS

ACKNOWLEDGMENTS

Late in the summer of 2011, inspired by a revived interest in the little mill village of Henry River, it became clear to us that this book must be written. It has been a labor of love—exhausting and rewarding—and first and foremost, we would like to thank each other.

We offer particular gratitude to the members of the Henry River Preservation Committee: Anita Brittain, Ray Burns, Richard Hefner, and Mel Newton, all of whom worked tirelessly to make this book possible. Our editors at Arcadia Publishing have also been extremely instrumental in this process and for that we are grateful.

We also wish to thank, especially, the many families of the Henry River Mill Village who took the time to take a walk into the past and share the stories and photographs without which this book would not exist. Additionally, we thank the Aderholdt family for the information and photographs they provided, many of which compose the first chapter, as well as Diane Fields, who granted us permission to use her haunting photographs in the final pages.

Our appreciation extends to Dottie Ervin of the Historic Burke Foundation for her wisdom and support; to Picture Burke in the North Carolina Room of the Burke County Library for access to files and information; to the Rockefeller Institute for providing space to write; to Connie Keller, who has single-handedly picked up trash along the road of Henry River for the past 12 years; to Nicole Keller for technical savvy, Louise Secordél for creative input, and Kelly Carroll for preservation efforts; to Pat Hoy for his infectious love of nonfiction; and to Mary Heaton Thompson, Kristin Dombek, and Linda Hefner for their early support and continuous encouragement.

Ruby wishes to give special acknowledgment to Evelyn Newton, Katie Childers, Paul Pope, and Robert Edwards for fielding her phone calls and fueling her inspiration. Nicole thanks, finally, her husband, Cody, and daughters Eva and Ella, who remind her that, even a world away from the village, all that truly matters is love, family, and the occasional slice of sweet, cold watermelon.

INTRODUCTION

Huddled in the foothills of North Carolina—not too far outside of Hildebran but clear on the other side of the county from Broughton, the state's largest mental hospital—there lies a near ghost town named Henry River Mill Village. The abandoned homes and Company Store are always eerie, but there is something in the light of dusk that makes them even more so; gap-toothed windows sprout trees, and slack doors open to couches that have not been sat on in years.

Just after the turn of the 20th century, Michael Erastus Rudisill arrived in the area and, inspired by the current of Henry River and the power he knew it contained, began to set up a cotton business. Rudisill and his brother Albert Pinkney Rudisill designed and engineered Henry River Mills on 1,500 acres of land purchased at $3 an acre. Others quickly followed, most notably David William Aderholdt, who served as a founder of the company and whose family eventually became the sole owners of Henry River Mills. D.W. Aderholdt and his son D.M. Aderholdt, known as Miles, managed the mill for the bulk of its operating years and were both known for their compassion and hard work.

When the mill began operations, it had about 100 employees, including children as young as nine years old. At that time, there were 4,000 spindles making carded yarn. In later years, at the mill's height, 12,000 spinning spindles produced more than 15,000 pounds of fine combed yarn each week, much of which was sent to New England for the lace and wire trade.

Near the mill, a housing development was built to accommodate the employees of the company. This village became the only planned mill community in Burke County history, and it is the people who were part of this village that make up the lion's share of this book. There were no notable landmarks in Henry River Mill Village, and most of the 35 worker's cottages were nearly identical. Each house contained four or five small rooms with an outhouse out back and a porch up front. Water was drawn from outdoor pumps and heated by sunlight or fireplace. What matters most about Henry River is not its structures but its people: how they lived and died, what they ate and longed for and prayed for, what they sacrificed, and what those sacrifices yielded.

The village peaked fast, but, sadly, it fell soon. In fact, it did not even make it to 70—an age many of us deem too young to die. In its time, however, Henry River was remarkable; it generated its own electricity, operated under its own currency, swam in its own swimming hole, and churned its own moonshine. Villagers played poker and baseball, they made quilts and blackberry dumplings, they spent their evenings playing music on the front porch, and they worked.

They worked hard. Longtime resident Bud Rudisill told of how he made only eight and a third cents an hour in his early days at the mill. Low wages meant scarce resources. Even worse during the Depression, meals were sometimes "nothing but tomatoes and sweet potatoes" given by someone with a little extra to spare. While the village did get electricity in the 1940s, it was often nothing more than a 40-watt bulb hanging in the middle of the ceiling. Running water, however, never made it to Henry River Mill Village. When it was too cold to get out back to the outhouse, villagers used a slop jar.

If you listen carefully to some of the stories, people wanted nothing more than to get off the hill, and yet even in those stories, there is a reverence and an abiding love for village life. For every tale of hardship and heartache, there are at least a dozen of joy and community. The prizewinning Moon-and-Star watermelons, the cooking up of cooters, and the fishing, drinking, and card playing—all of these came together to create joy in a place that might have otherwise been bleak, and threaded through that joy is a deep abiding love for the community.

During the war, when Walter Young fell in the mill and hurt his back, doctors told him that he would have to travel all the way to Winston for surgery. Since the tires on Walter's car were completely worn out, fellow villagers took the tires off their own cars and put them on Walter's; others donated ration stamps for gasoline, all making it possible to get Walter to the hospital in Winston. This outpouring of community compassion was appreciated but by no means unusual in Henry River Mill Village. And yet, the community that once thrived now sits empty.

Driving around the bend of Henry River Road, you might not feel the fear that gripped drivers back when the one-lane steel truss bridge still stood. Reputed as the highest bridge in North Carolina and argued to be the "scariest bridge in the world," it was replaced by a concrete bridge in 1960. What you will feel, however, when you round that bend is a sense of awe, a sense of "wait, where did everybody go?" The mill came to a sputtering halt in the early 1970s and burned to the ground in 1977. What remains are many of the workers' houses and the Company Store, a whole slew of blackberries and memories, and, perhaps most strikingly, a haunting silhouette of the industrial heritage of North Carolina.

In recent years, Henry River Mill Village has become an inspiration for artists. Writer Tim Peeler has written dozens of poems about the village. Photographer Diane Fields has captured heartbreakingly beautiful images. In May 2011, Hollywood took over the village by choosing it as an important location—the grim District 12—for its $75-million postapocalyptic film, *The Hunger Games.*

Many former villagers, of course, take a certain pride in knowing that a place they once called home now serves as a backdrop to something so pervasive. There are, however, many who do not see this as enough. In the spring of 2012, the Henry River Preservation Committee has been instated under the umbrella of the Historic Burke Foundation. This committee seeks not only to preserve what remains of the tiny village that sits picturesquely on the steep contours of the river's northern bank but, most essentially, to preserve the memories of all those who once called Henry River Mill Village home.

One

THE MILL

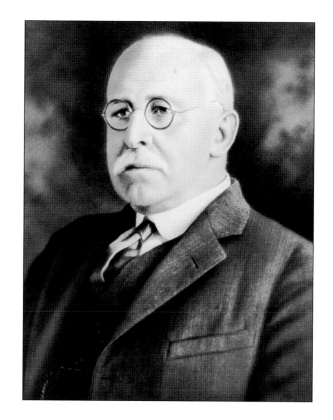

In early 1900, Michael Erastus Rudisill came to Henry River from Cherryville, North Carolina, with the idea of building a cotton mill. In 1905, the 4,000 spindles of Henry River Mills began manufacturing fine-combed yarn. Original stockholders sold out in 1917 to David William Aderholdt, John George, and Marcus Mauney. A new company was formed, and D.W. Aderholdt, pictured, served as general manager until his death. (Courtesy of Faye Poteat.)

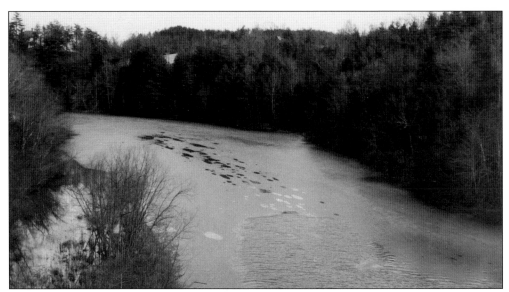

Michael Erastus Rudisill, having purchased about 1,500 acres at $3 per acre, surveyed the land and figured the fall of the river before building the dam. Albert Pinkney Rudisill took over the engineering of the dam. Made of reinforced concrete, the dam contained large abutments on the downstream side and approximately a 30-foot head. The mill was entirely run by water until 1914, when a steam plant was added to supplement the power. In 1916, a flood destroyed the top portion of the dam, and sandbags were banked against the mill to protect it. During the two years it took to rebuild the original dam, a temporary dam sufficed. Each year, the mill generated 75 percent of its power from November to late spring when there was plenty of water to drive its generators. (Both, courtesy of the Aderholdt family.)

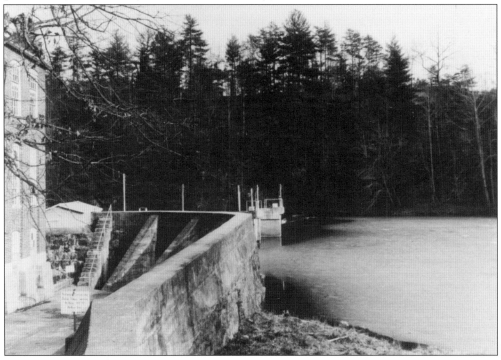

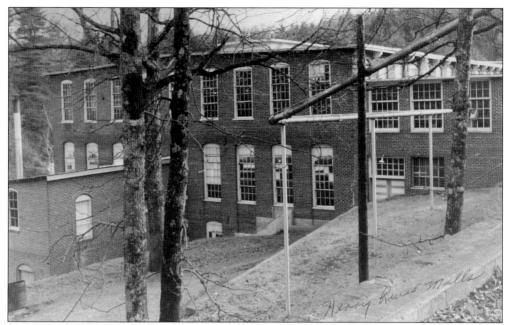

The main mill building was a large three-story brick structure, which burned in 1977. Only its foundation remains. In its time, the Henry River Mills Company worked hard to revolutionize its mechanical operations. By 1907, the 4,000 original spindles doubled in capacity, and at the mill's height, there were 12,000 spinning spindles producing more than 15,000 pounds of combed yarn each week. Near the mill, a housing development was begun to house the operators and employees of the company. This village became the only planned mill community in Burke County history. (Both, courtesy of the Aderholdt family.)

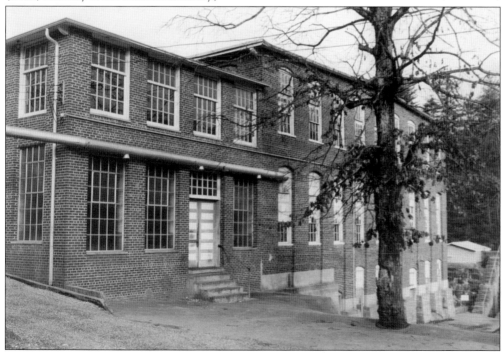

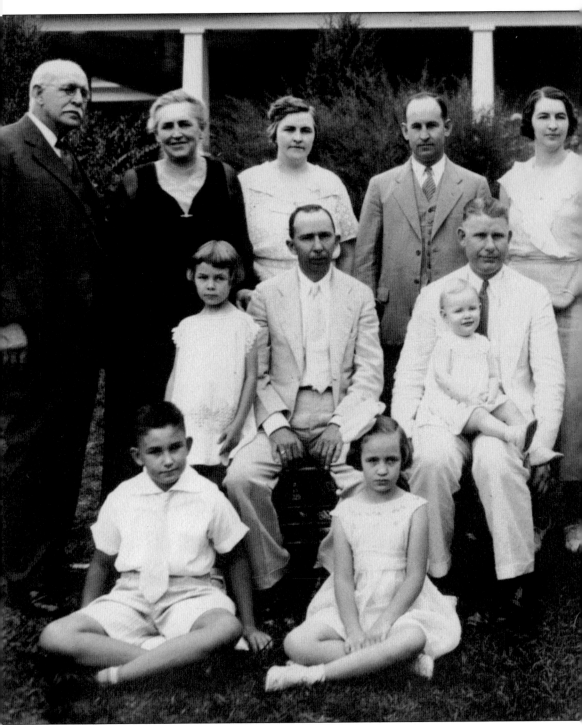

The Aderholdts became sole owners of Henry River Mills in 1929. After the death of Cap'n Will, as D.W. Aderholdt (third row, first from left) was affectionately known, the mill business was carried on by his children. Hal Aderholdt (third row, sixth from left), whose early death in 1951 shocked many, served as vice president of the firm and manager of the Company Store. D.M.

Aderholdt (third row, fourth from left), known as Miles, was village postmaster, secretary-treasurer, and general manager of the plant and business. In the nearly 40 years that Miles managed the company, he was deeply respected for being a hardworking, compassionate leader, asking no more of others than he was willing to do himself. (Courtesy of the Aderholdt family.)

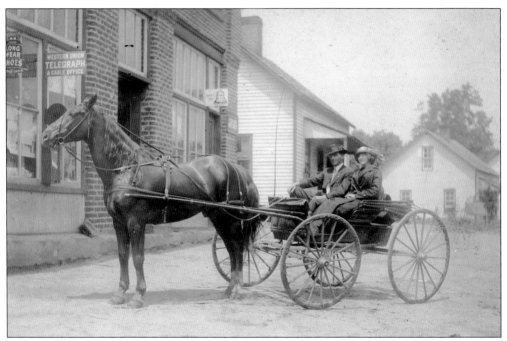

In this beautiful portrait from 1913, Carl Mauney, a brother of Vivian Mauney Aderholdt, sits in a horse and carriage in front of the Company Store with his bride, Florence Campbell. Carl ran the Company Store briefly before returning to Cherryville. In the background, the painted trim that adorned the village houses can be seen. (Courtesy of the Aderholdt family.)

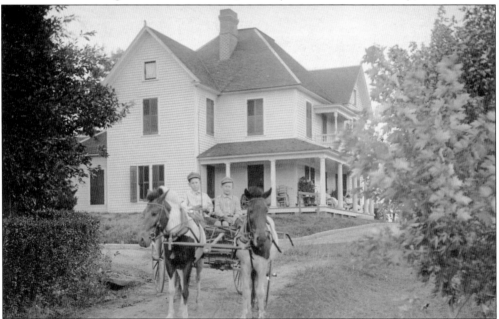

Around 1907, the four owners built new homes just outside the village to make more room for the employees and to accommodate their own families. Out in front of the D.W. Aderholdt home, on a cart pulled by two horses, Hal (left) and Miles Aderholdt are ready for a journey. (Courtesy of the Aderholdt family.)

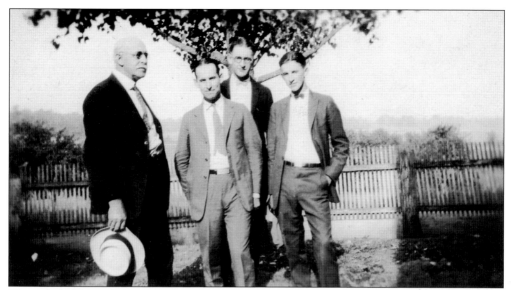

The Aderholdt yard was a haven for the family who loved the outdoors. Miles's great desire was to have a new dogwood. Several years before his death, Miles purchased a mule so he could plow his own garden, which he was doing when he suffered a heart attack and subsequently died. Standing with his sons, from left to right, Miles, Hal, and John, D.W. Aderholdt (far left) strikes a powerful pose. (Courtesy of the Aderholdt family.)

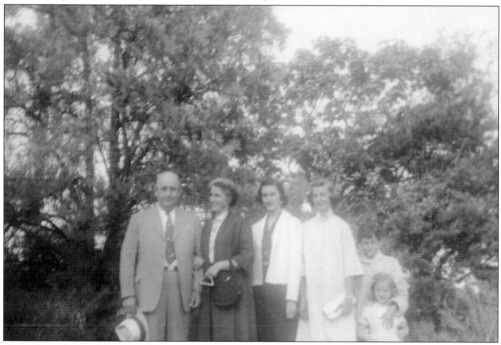

Even though he did not make it to the birth of his fourth daughter, Faye, because he was busy at work for the "Drawing Off" of the dam, Miles Aderholdt treasured his daughters. Perhaps his most affectionate gesture was converting his mother's former greenhouse into a dollhouse; it still stands today. The Aderholdt family looks happy and relaxed; they are, from left to right, Miles, Marie, Nanette, Rita, Janice, and Faye. (Courtesy of the Aderholdt family.)

Henry River winds in front of the Aderholdt house, and Miles loved sitting on the porch and looking at the view. He believed nothing could be more beautiful. His daughters remember that, after a long, hard week of work for Miles, the family members savored their time together as they wrapped themselves in blankets, settled into rocking chairs, and watched the mist settle over the hills. (Courtesy of the Aderholdt family.)

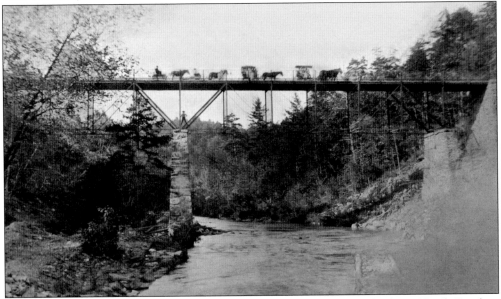

Built in 1912, the one-lane steel truss bridge was reputed to be the highest bridge in North Carolina and argued by anyone whoever crossed it to be the "scariest bridge in the world." Until the bridge was built, all travel crossed by fording the river. In 1960, the bridge was replaced by a concrete one, but it fueled nightmares for years to come. (Courtesy of Joel and Anne Aderholdt Reece.)

Two

WORKING HARD

In order to quell nicotine cravings during long shifts, many workers dipped snuff or chewed tobacco. Packaged in a small can that could easily be carried in a pocket, the ground tobacco leaves were placed between the teeth and lower lip. Once out of the mill, many workers, like these, rolled their own cigarettes from tobacco and cigarette papers and enjoyed a smoke in the sunlight. (Courtesy of Evelyn Newton.)

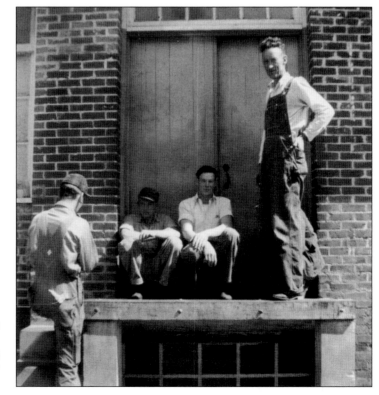

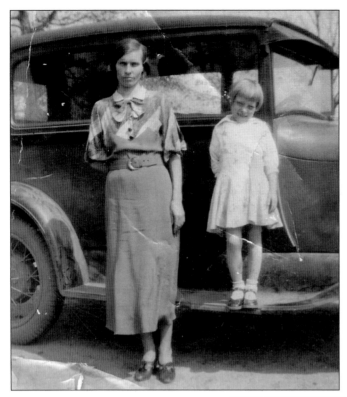

Born in 1903, Kate Young Lynn, left, started working 12-hour shifts at Henry River Mill when she was nine years old, working until the mill closed in 1973. Kate then found employment at Lindsay Hosiery and, eventually, worked from home, where she sewed sheets well into her 90s. Living happily at home and working in her garden, Kate lived to be 105 years old. (Courtesy of Evelyn Newton.)

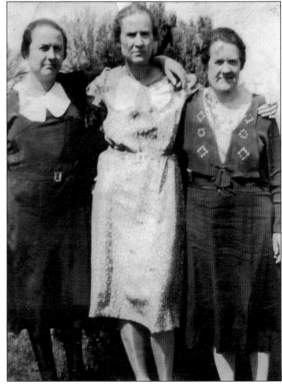

These three sisters, from left to right, Minnie, Nanny, and Mandy Lail, came from Shady Grove to work in Henry River in the early 1930s. Although Minnie was born club-footed, she worked 12-hour shifts alongside her sisters until 1938, when the Fair Labor Standards Act instituted eight-hour shifts. The first minimum wage was a welcome 25¢ per hour. The sisters never married and lived together until their deaths. (Courtesy of Larry Robinson.)

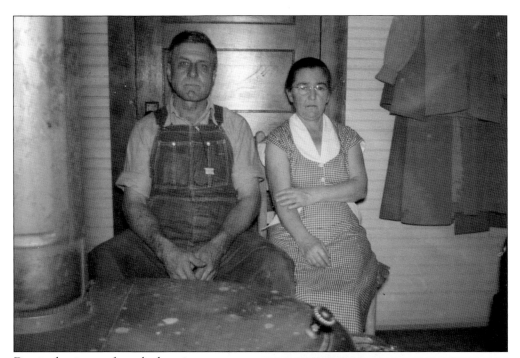

Despite having no formal education, Walter Young was a skilled mechanic who kept the mill up and running. When a different thread was to be made, he changed all the gears on the combers. Even after he retired, he was often asked by Miles Aderholdt to come back for a day to do repairs. Young also cut the hair of the men on the hill. (Courtesy of Ruby Keller.)

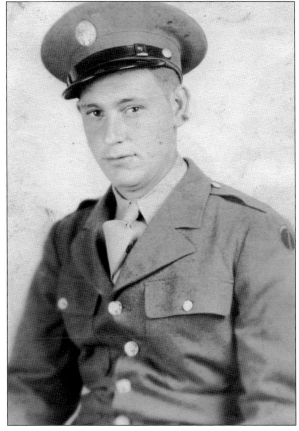

In World War II, William Johnson was hit in the back by shrapnel and spent 18 months as a German war prisoner. Upon returning home, Johnson went back to the mill to run twisters. Every morning before school, his sons Wayne and Ronnie, 11 and 12 years old, would work the last three hours of his shift, allowing him to lie on plywood to rest his throbbing back. (Courtesy of Anita Brittain.)

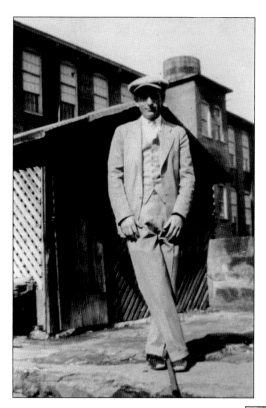

In the early days, the mill generated its own power with water. There was a big open wheelhouse that ran the length of the mill, and through this shaft were wide belts and ropes that were about three inches in diameter. When one of the ropes broke or became worn, the only person who could replait the ropes without knots was Bill Cline. (Courtesy of Frances Beckom.)

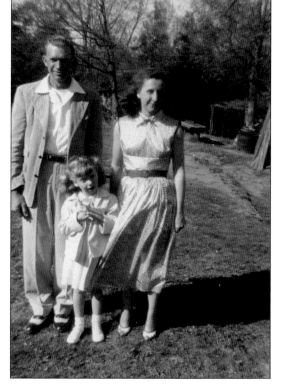

Oscar Burns, left, helped Bill Cline with most of the grounds maintenance. They trimmed shrubs and trees and mowed the grass with a hand sling when power mowers were unavailable. They took trash to the end of the village where a high bank served as a dump. In spring and summer, the men worked in the Aderholt garden and were served tomato sandwiches for lunch. (Courtesy of Ray Burns.)

On weekends, watchmen made hourly rounds of the mill. Between rounds, they had to clean the machines. Paul Pope loved it when his daddy, Andy, right, watched because he and his brothers spent hours playing on the big freight elevator. When the elevator stopped at a floor, it had to be manually leveled. Safety did not seem to be an issue in the early days. (Courtesy of Louise Brittain.)

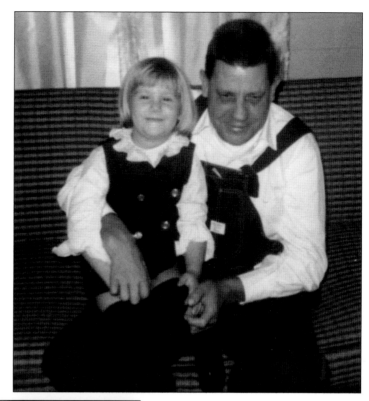

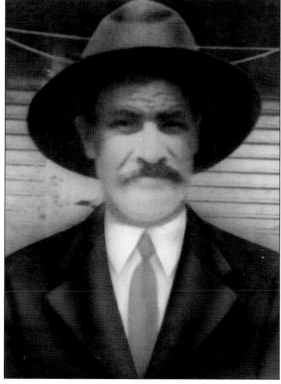

Amzie (pictured) and Alice Pope operated a boardinghouse. According to their grandson Paul Pope, workers were brought in by bus each week and went home for the weekends. In the 1930s, when some workers became able to buy cars or opted to walk miles from home every day, there was no longer a need for boarding, and the building was rented to residents for living quarters. (Courtesy of Paul Pope.)

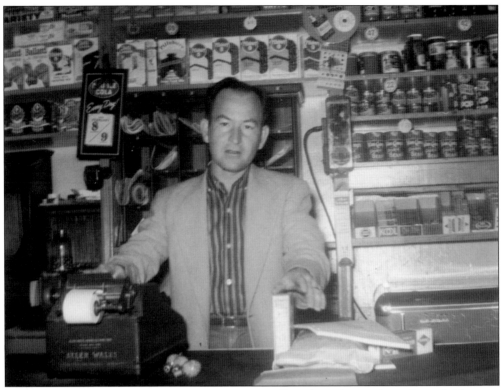

In order to better themselves, thrifty people worked hard long hours. In the mornings, Edward Childers worked in the Company Store and then went to the mill to work the second shift. The $25 a week that he earned in the store was saved to purchase a 1935 Ford, which was the first car owned by him and his wife, Katie. (Courtesy of Katie Childers.)

Prior to the Fair Labor Standards Act, people were not paid during training for a job in the mill. This was the case of Myrtle Young Gilbert, who went to work in 1939 at the age of 16. When the labor board began to investigate plants, Myrtle, along with a number of other people, was given back-pay for her hard labor. (Courtesy of Ruby Keller.)

As a young teen, Katie Young Childers worked in the Aderholdt home, helping with children, cleaning, and doing the laundry. Her favorite task was to iron Miles Aderholdt's shirts because she got to use the electric iron. Mill houses did not have electricity at the time; back at her home, flat irons were heated on the wood stove and held by folded rags when the handles got too hot. (Courtesy of Katie Childers.)

Although he had little formal training, John Henry Young was the community automobile mechanic. He was famous for being able to repair anything that went wrong with a car or truck. Employed at a junkyard, John helped residents out on the side by keeping their vehicles running at a very low cost. (Courtesy of Anita Brittain.)

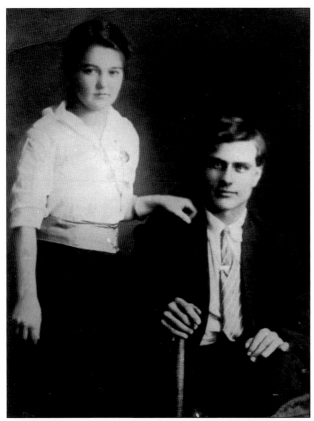

Walter Young and Martha Robinson met while working in the mill. They married in 1916, when he was 21 and she was 14, and then moved to South Carolina, where Walter worked in sawmills. When the Great Depression hit in 1931, they returned to Henry River. Unable to procure a job, Jessie Raby let Walter work one of his days so Young could support his family. (Courtesy of Ruby Keller.)

In the early years, there were no vending machines in the mill. Every day, the Company Store sent around a lunch wagon, or dope wagon, as many called it. If they could afford it, workers could purchase sandwiches, pies, and drinks. These goods could also be charged to their account at the Company Store. (Courtesy of Anita Brittain.)

Child labor laws were not in effect in 1929 when, on the ball field riding a scrape being pulled by a mule, Andy Pope, right, got his hand caught beneath the scrape. He was 13 years old and, as there was no car available to take him to a doctor, he lay on the field for hours without medical attention. He received no compensation for the injury, which disabled his hand for life. (Courtesy of Paul Pope.)

Machines in the mill could be dangerous. In the late 1940s, Blanche Newton Hames's hand was caught in a winder machine. She was driven by car to Duke Hospital and spent a number of weeks there. Evelyn Lynn and Maxine Newton hired an ambulance from the funeral home to transport Blanche back from Durham. Absent from work for months, Blanche lost two fingers in the accident. (Courtesy of Evelyn Newton.)

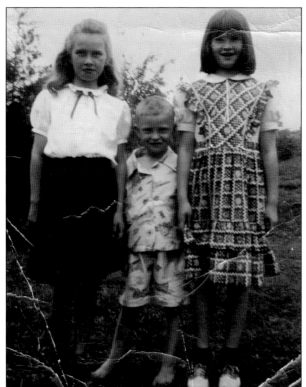

One night, Howard, center, and Larry Hudson went to the mill with their dad, Fred, while he worked as a watchman. Due to a storm, electricity was knocked off, and when Miles showed up to check on things, he asked Fred to turn the power on. Fred felt it was too dangerous and refused. Often during storms, fire was on the lines between the houses. (Courtesy of Howard Hudson.)

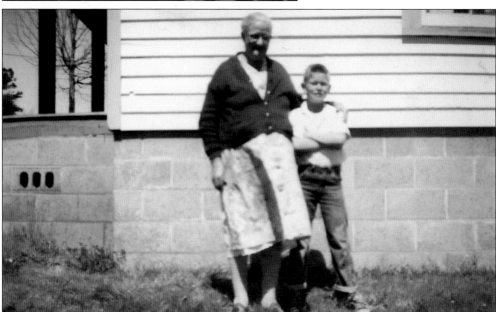

Ellen Hicks Rudisill spent most of her life working and living on the hill. After the death of her husband, Wade, in the 1930s, she had difficulty keeping food on the table for her six children. Once a neighbor gave them sweet potatoes, which served as breakfast, dinner, and supper until the pile was gone. Between gardening, fishing, and neighborly love, the family managed to survive. (Courtesy of Anita Brittain.)

Mollie Cline Brittain grew up in the village and went to work as a spinner at a young age, continuing to work while raising her children, until retirement. After her marriage to George, she moved to the George Hildebran area. The couple often hosted corn shuckings on their farm. Once the corn was shucked, there was a big dinner of chicken and dumplings. (Courtesy of Anita Brittain.)

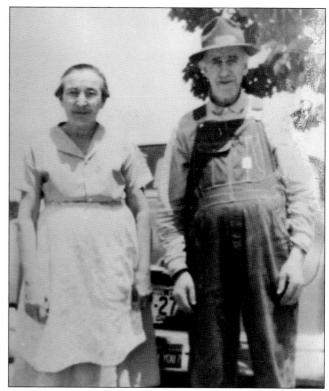

At the age of 12, Daniel "Bud" Rudisill went to work as a doffer in the spinning room. When he was 17, his father passed away, leaving a large debt at the Company Store. Being the eldest of the children, Bud took over as head of the house, helping his mother, Ellen, pay off the debt and rearing his younger siblings during the Depression. (Courtesy of Anita Brittain.)

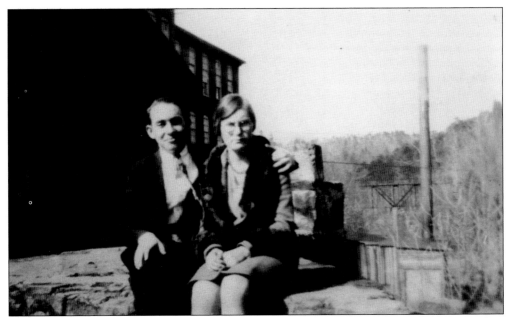

In front of the smokestack, which was located on top of the boiler room, Bessie Herman Cline and Rob Holman pose for this 1929 photograph. A wood furnace and steam pipes brought heat and power to the mill. Picturesque, this spot served as a favorite locale for photographs. (Courtesy of Frances Beckom.)

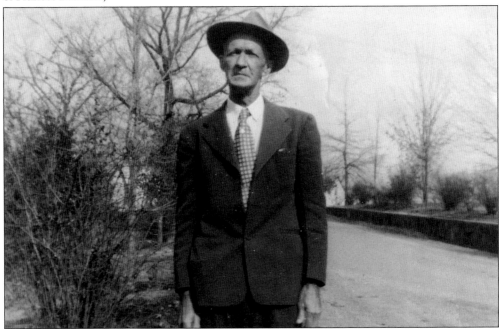

After the death of his father, Frank Sr., Frank Newton moved with his mother, Fidelia, to Henry River. As the years passed, the mill owner recognized Frank's abilities and promoted him to be overseer of the card room. Frank's wife, Laura, ran spinning frames. Most of their six children worked at the mill before marrying or moving onto other jobs, thus encapsulating the transient nature of the hill. (Courtesy of Evelyn Newton.)

In the 1930s, after a 12-hour night-watch shift, John Pope was found hanging from a pipe with a millband around his neck. A bucket had been kicked from under his feet. Suspecting that he might not have taken his own life, the company instigated a two-person shift for night watch. Pictured here is his wife, Lucy, with their daughter, Edith. (Courtesy of Paul Pope.)

In 1914, at age 11, Fannie Young Cannon began running winders and held that job until mill operations ceased. Conditions were hot and dusty; when workers finished their shifts, they used an air hose to blow lint from their bodies. To get through days of pain, workers often washed down headache powders with a Coca-Cola, or "dope," as it was called. These powders were marketed to mill workers. (Courtesy of Evelyn Newton.)

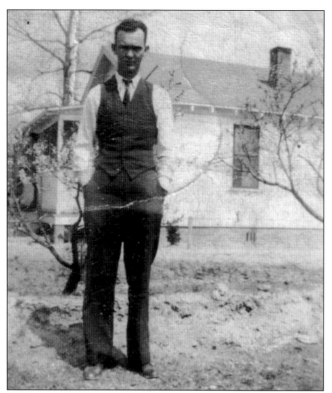

When he became employed at the mill at the age of 10, Walter Childers earned 8¢ per hour. After years of hard work and self-teaching, he eventually became second-shift supervisor for the spinning, spooling, and winding rooms. Recognizing that many men in the mill could not read, write, or count money, Childers taught them how to do so in the upstairs of the Company Store. (Courtesy of Beatrice Brittain.)

During World War II, while the men fought in the war, Maxine Newton Hefner ran Slubbers—the machine that began twisting cotton into yarn—in the card room. Before the war, card room jobs had been strictly for men. Because it was taking so long for women to run upstairs to where the "women's jobs" were for a restroom, it did not take long for a new one to be added. (Courtesy of Richard Hefner.)

Annie Mae Young Rudisill remembers sewing dresses from floral-printed animal-feed sacks. During World War II, Annie Mae worked in the mill. At that time, the government issued a minimum wage order. Although Annie did not receive minimum wage then, she later received back-pay when it was discovered that owners had not paid the full amount. (Courtesy of Annie Mae Young.)

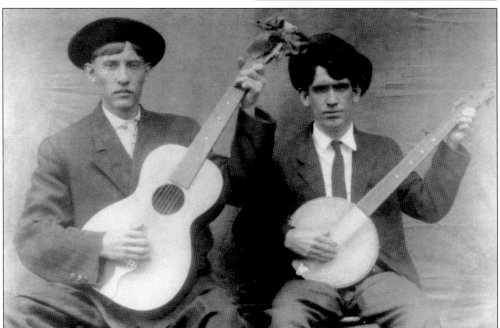

John Frank Bollinger, right, was first-shift supervisor in the card room. In his 30s, he lost three fingers on his right hand while attempting to dislodge an item from a card machine. Never again was he able to play the banjo or the mandolin, but he continued to fiddle. Here, he strums with a guitarist friend before the accident. (Courtesy of Janie Green.)

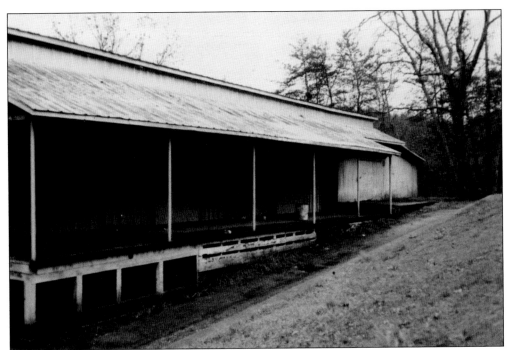

Honoring family tradition, Ray Burns quit school at 16 to work in the mill. Huge bales of cotton were lowered from the warehouse into the Opening Room, and it was Ray's job to take the layers of cotton to a conveyor belt, which fed into a machine that combed the cotton. Afterwards, the cotton was moved via suction tubes to the card room. Since the conveyor belt was slow moving, Ray learned that he could fill it with cotton, tie one end of the string to a conveyor rung and another to his ankle, and indulge in a 30-minute nap. One afternoon, Ray felt a tug at his ankle and jumped up to realize it was not the machine tugging him but Miles Aderholdt. Unfit for millwork, Ray returned to school and eventually became a pharmacist. (Both, courtesy of Ray Burns.)

Glenda Young's mother, Eva, worked as a watch-person after the mill closed. After Eva's husband, Charlie, became disabled, Eva put the children in the wagon, hitched up the horse, and went out to plow neighboring gardens for $3 per field. Eva and Marie Lynn are thought to have been the last workers at Henry River Manufacturing Company. (Courtesy of Glenda Young.)

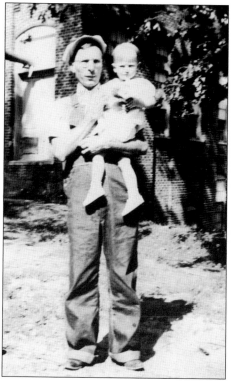

Since maternity leave was not a part of the mill-working woman's life, mothers went back to work soon after their babies were born. As bottles were not available, the caregiver brought the infant to the mill to be nursed. Virgil Buff remembers Tate Pope Jr. was one of those babies. Here, the young Tate is being held by his father, Tate Pope Sr. (Courtesy of Zeno Crump.)

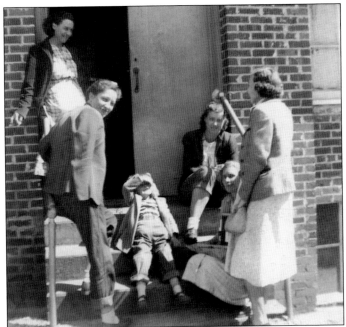

Hazel Young, Fannie Cannon, Edna Kizer, Kate Lynn, and Bertie Lindsay (half-circle from left) wait on the mill steps for shift change. Sherry Newton, who sits on the steps, will also be handed from her Grandma Kate to her mother, Evelyn Newton, who will be leaving work. In order to save money and provide optimal care for their children, family members often worked opposite shifts. (Courtesy of Katie Childers.)

Like most village girls, Beulah Rudisill Raby met her husband, J.P. Raby, in Henry River. They moved into house No. 3 where their children were born. J.P. died at a young age, leaving Beulah to raise Susie and Jesse while working in the mill. Although the mill closed in the 1970s, Beulah did not want to move out of her longtime home and stayed until her death. (Courtesy of Anita Brittain.)

Workers who struggled between paychecks often relied on company money, called Doogaloo, to keep them going. During the week, if a worker needed something from the store, a "scrip" was written for the amount of purchase, and change was given in Doogaloo. The amount of the scrip then came out of their weekly pay. Minted in zinc, Doogaloo were ordered by the company from 1911 to 1942 in coin denominations of 5¢, 10¢, and 25¢. Records indicate that management made particular use of the tokens during the Depression and World War II. Rarely seen today, corrosion of the zinc might account for the scarcity of Doogaloo. (Courtesy of Mel Newton.)

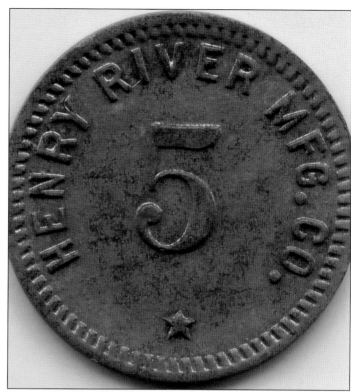

Henry River Mills Co.

NAME......... Rose Cline

Week Ending...... 7/11/70

Regular	18 hrs. @ 160		28	80
Overtime	hrs. @			
Amount Earned			28	80
DEDUCTIONS				
Bal. Brt. Forward				
Store Account				
Rent				
Fuel				
Power				
Loans				
Federal Tax		—		
Soc. Sec. Tax		1 38		
State Tax		19		
Total Deductions			1	57
Balance Paid			27	23
Bal. Due Mill Co.				

In 1973, Henry River Mill ceased operation completely. Rose Cline's pay envelope with a meager 18 hours of work at $1.60 per hour depicts the slow death of textile mills in the United States. Many jobs moved overseas, and cotton mills closed their doors forever. At the time this happened, Rose was 66 years old and had worked in the mill for over 50 years; it was the only life she had ever known. As the 12,000 operating spindles came to a decisive halt, the close-as-family life of living in a small village and working in the mill was over. (Courtesy of Adam Willis.)

Three

LIVING HARD

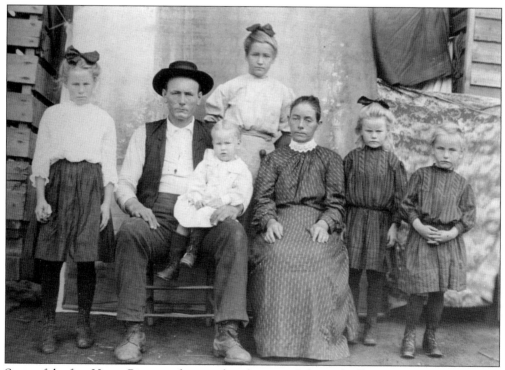

Some of the first Henry River residents and workers were John and Lillie Herman. Their children were, from left to right, Osha, Pearl, Julie, Artie, Lester, and Bessie. Many years later, when John died, Lillie moved in with her daughter and son-in-law, Bessie and Bill Cline. While the couple worked in the mill, Lillie worked hard caring for the grandchildren and doing chores. (Courtesy of Frances Beckom.)

In the very early years, there was an old house in Hullet Spring where Maggie, right, and Garland Lail's father, Walt, lived. One day, Walt and his wife, Dovie, had an argument; hours later, Walt discovered footprints in the snow going to the river. He was worried until he discovered she had faked her death and walked backwards in the same tracks to return home and hide in the attic. (Courtesy of Katie Childers.)

In the 1930s and 1940s, Tom Townsend lived in and operated a little store just outside the village. Since the Company Store closed in the early afternoon, Tom's was busy in the evenings. He married Emma and had a daughter Ainer, right. Ainer later operated the store with her blind husband, Sam Pope; to the next generation, the store became known as Sam's Store. (Courtesy of Frances Beckom.)

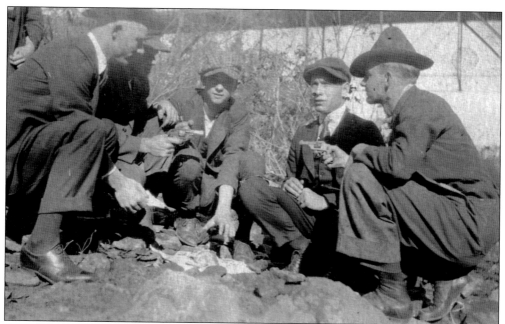

Around 1933, from left to right, Doc Abee, unidentified, Guy Young, unidentified, and Henry Childers seem to be enjoying a not so friendly game of poker under the old Henry River Bridge. All dressed up in suits and with guns displayed, it is believed that this photograph was made for a newspaper contest. Poker was one of the favorite avenues of entertainment in the village. (Courtesy of Evelyn Newton.)

Money was scarce, and home permanents were cheap. In addition to working full time at the mill, Margaret Reep became the community "beautician." Although she had no formal training, Margaret shampooed, cut, styled, and gave permanents. This not only supplemented her income but helped women in the village who could not afford beauty shops. (Courtesy of Susie Childers.)

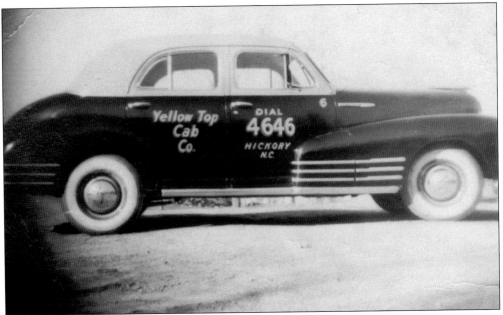

Henry Lowman was one of the first residents to own a car. He afforded workers the opportunity to break away from the Company Store by providing a taxi that would take them to nearby Hickory to purchase groceries. The fare was 10¢ per round-trip ride. Henry later started the Yellow Top Cab Company in Hickory, shown in this Christmas card sent out by the company. (Courtesy of Melvin Newton.)

Susie Reep Childers never worked in the mill but still managed to meet her husband, Robert, there. In order to see Robert, Susie delivered cups of coffee to her friend Blanche Newton Hames when she was working. After the young couple became engaged, Blanche no longer received free coffee service. (Courtesy of Susie Childers.)

"Fuzzy" Edwards, back right, and "Soapy" Newton, back left, worked the second shift at the mill. After the women had gone home, they would strip, climb over the reservoir fence, and cool off. One night, some women were walking by. They stopped at the boardinghouse and, with raised eyebrows, asked Doug Crump, who had a room there, what was going on. Trying to keep Fuzzy and Soapy's secret, he replied that there were some "big fish" in the reservoir. (Courtesy of Melvin Newton.)

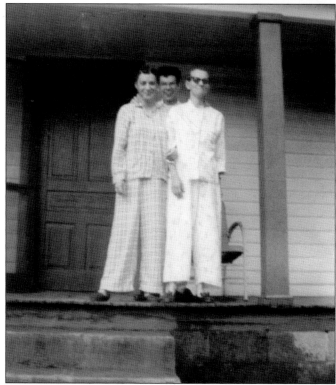

Blanche Newton Hames, left, and Margaret Reep, right, both divorced and with children to raise, stretched their incomes and bettered their livelihoods by sharing a house and expenses. In order to eliminate paying for childcare, the two women alternated shifts in the mill; thus, one of them was always home to be with children Rickie, Susie, and Doug. (Courtesy of Susie Childers.)

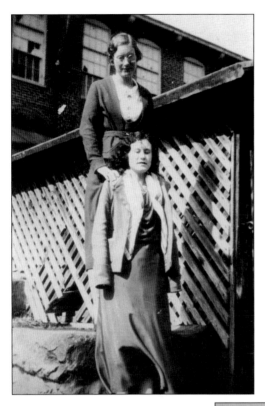

In 1937, Ethel Smith Hand, front bottom, lost her life as well as her newborn during childbirth. She left behind a small son named Clarence. Henry River had its own informal welfare system, and several neighbors volunteered to take Clarence in. His grandmother Osha decided that Harvey and Ola Hudson should take him into their home and raise him as their own with sons Archie and Bill. (Courtesy of Frances Beckom.)

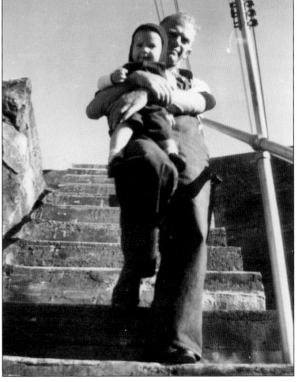

People in the village received little or no medical care. Leroy Burns, who worked as an oiler, had been sick for a while when Dorse Johnson took him to see Dr. Hunsucker. Rumor has it that when Leroy returned to the car, he asked Dorse what a specimen was. The next day, Leroy went into the doctor's office, apologizing for not filling the gallon jug. (Courtesy of Ray Burns.)

Around 1931, Katie Young Childers, right, was a child, and Henry River experienced a bedbug infestation. At the time, no sprays or powders were available, so people heated water on the woodstove to pour on walls and floors. When the company relented to installing new floors and painting the walls, the bedbug problem was solved for most people. (Courtesy of Katie Childers.)

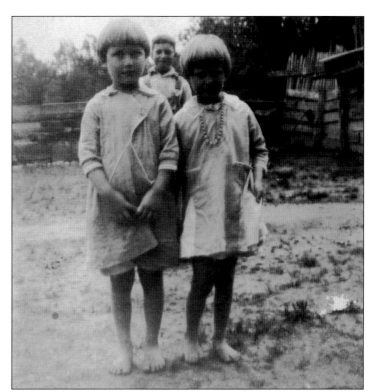

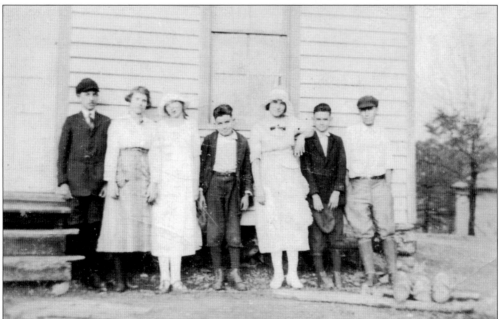

Because farm life was hard with very little income, six of the Young children, who were born between 1896 and 1903, left Camp Creek at a very young age to live and work in Henry River. Most of the six worked in the mill until they died, retired, or the mill closed. Standing side-by-side are, from left to right, siblings Marshall, Mandy, Katie Everette, Fanny, Guy, and Walter Young. (Courtesy of Evelyn Newton.)

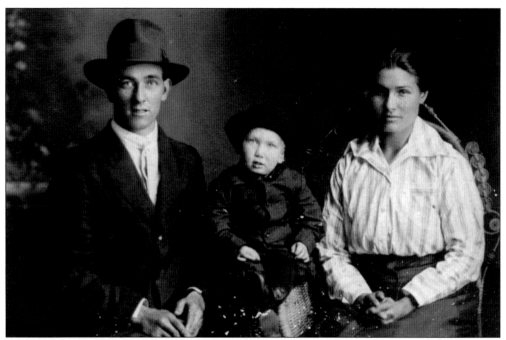

In the first half of the 20th century, there was no medical insurance and very little medical care. The few doctors in the area made house calls. Odis Young Lynn, above left, developed a terrible flesh-eating cancer on his face and neck. He was bedridden, and bandages were made by tearing old sheets into strips. At age 43, he died a painful death. (Courtesy of Ruby Keller.)

Peggy Edwards Teague remembers that as winter approached, residents ordered coal from the company for heat. Money was deducted weekly from their pay. For their wood cooking stoves, residents bought scrap lumber from Cox Lumber for $10 per load; the wood was stored in a dry space under the house. It is unknown how much money the company made off the coal. (Courtesy of Peggy Teague.)

David Young, born in 1868, carted wagonloads of wood from his farm on Camp Creek to his children who lived in Henry River. After his wife, Julia, died in 1936, he came to the village to live with his daughter Katie Lynn and be near his other children. He never owned a car and would travel to Newton by wagon to serve on the jury. (Courtesy of Evelyn Newton.)

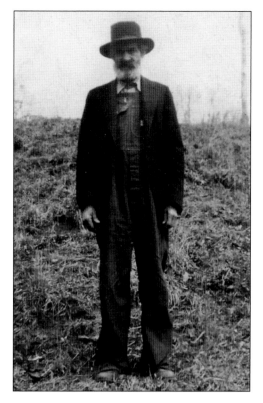

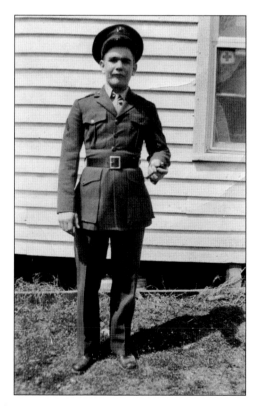

In 1951, a poker game was in progress on the old dirt road near the trash dump when Ray Cline was shot in front of Will Cline's store. Paul Pope was sent to interrupt the game and tell Ray's brother Herman Lynn (pictured) that Ray had been shot. The poker players armed themselves to search for the shooter. Law enforcement found him first and prevented further bloodshed. (Courtesy of Diane Eckard.)

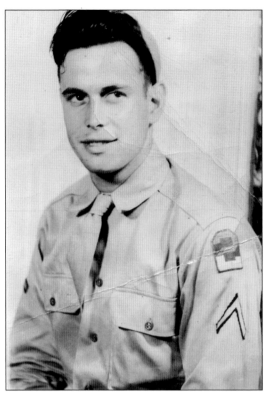

Ray Cline was the only Henry River resident to be murdered in the village. In 1951, he was walking with "Duck" and Frank Hudson in front of Will Cline's store when he was shot in the stomach with a sawed-off shotgun. Many say the shooting was not because of all the drinking and poker playing in the village but because Ray was seeing another man's girlfriend. (Courtesy of Diane Eckard.)

Like many others, Betty Marie Lynn, left, wanted to leave Henry River for a better life. She hated working in the mill and hated the way outsiders looked down on mill life. The mother of three, she owned a beauty shop in Icard and later moved to New Jersey. It is unknown whether she ever felt life got better than it was on the hill. (Courtesy of Diane Eckard.)

On the morning of August 21, 1966, Roy Rudisill, pictured, and Jackson Scruggs took out peace warrants because Boyce "Doc" Liverett had threatened to shoot them. Deputy Joe Burns went to find Liverett at the home of Alma Cline to serve the warrants. What followed stands as arguably the darkest day in Henry River history. After a standoff, Liverett shot and wounded Burns and killed Sheriff David Oaks. Ray Burns (no relation to Joe) remembers sitting on his parents' porch when Liverett walked casually up and sat with him, saying he had heard gunshots. After resting, Liverett walked to Sam Pope's store and was sold more ammunition by the unknowing Pope. Spawning one of the most intensive manhunts in the county's history, the 62-year-old Liverett, a fixer employed by the mill, was sentenced to prison and paroled prior to his death in 1989. (Above, courtesy of Ray Burns; below, courtesy of Bobby Abernathy.)

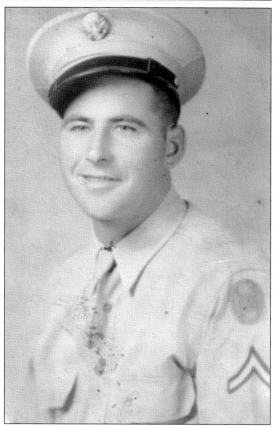

As was common in the village, Dave and Mary Watts Johnson made their home with several of their children and grandchildren. When Dave developed tuberculosis, he was sent to the sanitarium in Black Mountain for isolation. There, he stood on the balcony and waved to his children. As late as 1947, the US Public Health Service performed X-rays and issued certificates of wellness for tuberculosis. (Courtesy of Anita Brittain.)

During World War II, at 17 years of age, Leroy Burns joined the Army. Burns was sent overseas, where he served as a short-order cook and as a Jeep driver for General Eisenhower. The winters in Europe proved harder than the ones in Henry River. Short in stature, Burns sometimes had to be carried by his buddies because the snow was so deep. (Courtesy of Ray Burns.)

On the day after their marriage, Bud and Hettie Johnson Rudisill pose on the old Henry River Bridge. Like most residents, the Rudisills did not own a car and walked everywhere. Along the edge of the river, paths went up and down for miles. One of the longest paths went to Brookford Mill hill, where Bud's relatives lived. The families often walked back and forth to visit. (Courtesy of Anita Brittain.)

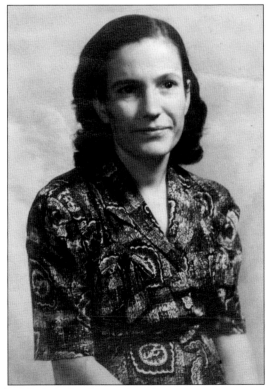

When she was a young girl, Diane Eckerd's aunt, Alma Cline, pictured, bought her a beautiful Cinderella doll, which stood as tall as the girl. The doll must have taken a huge chunk out of Alma's paycheck. After her only child, Kenneth, known as Pete, was accidentally killed when running into the road to retrieve a ball, Alma developed a particular fondness for Diane. (Courtesy of Diane Eckard.)

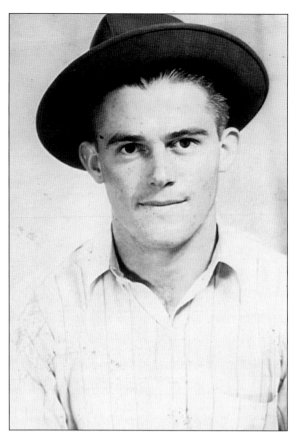

Brenda, Steve, and Ernie Burns kept their dog Spud chained at the door to the crawl space under the house. One of the Gross boys had broken out of prison and befriended Spud. As Spud kept watch, the young man lived under the crawl space for two weeks before being discovered by their father, Virgil, pictured. (Courtesy of Steve and Janice Burns.)

Sallie Smith Lowman worked as a spinner in the mill. In 1940, her husband, Clinton Lowman, pictured, decided they should move to Wilmington so he could be a welder in the shipyard. Two years later, called to service, Clinton—wanting Sallie to be near family and resume work at the mill—traded his horse to Hal Aderholdt in exchange for Bill Cline to bring the Henry River Mill truck to move them back home. (Courtesy of Clinton Lowman.)

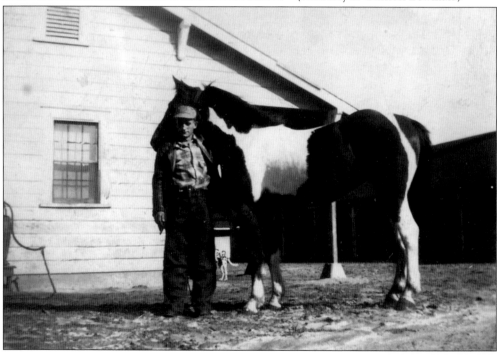

Leroy Duckett, center, enjoyed throwing parties at his house at the bottom of the hill. One evening, Leroy, who had just purchased a late model car, insisted on driving Cordell Hildebran home, just a few hundred yards uphill. The two barely got out of Leroy's yard before hitting two parked cars and totaling the one Leroy has just purchased. Cordell made his own way home. (Courtesy of Vernon Duckett.)

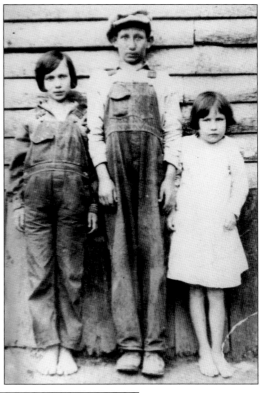

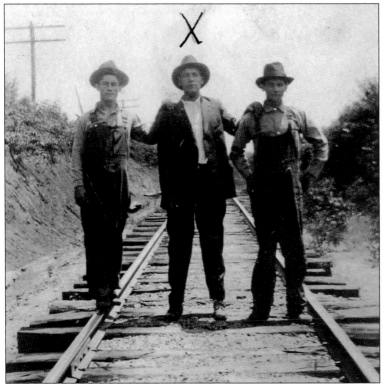

Guy Young, center, thrived on playing poker and making moonshine. His competitors, however, were not happy with his success. On the night of April 15, 1932, Guy went foxhunting with a group of men. Several were sleeping in a barn near Camp Creek when it caught fire. Young's body was found inside. It was never discovered how the fire started. (Courtesy of the Young family.)

Rumor had it that Everette and John Henry Young's moonshine still was to be raided. Robert Edwards, above, third from left, informed John's wife, Hazel, who went to warn the men of the raid. Hearing vehicles approaching, all who were involved ran to avoid arrest. Not long after, an unusual still was found downriver. Law enforcement took it to Morganton to be displayed in front of the courthouse. (Courtesy of Robert Edwards.)

In the late 1940s, Craig Lynn turned the upstairs of his house into a photography studio complete with a darkroom for developing. Craig's wife, Marie, could add color to the photographs at the customer's request. The business thrived. Pictured here are Craig and Marie along with Craig's mother, Mandy, and brother J.D. and children Scotty and Tony. They all lived in house No. 17. (Courtesy of Gary Lynn.)

Because of complications during his 1931 birth, William Young suffered from mental disabilities. He was, nonetheless, a staple in the community and seemed to live a carefree life among the residents. He once walked into Miles Aderholdt's office and asked if he could have the river. The answer was simple: "Yes, but you can't take it with you." (Courtesy of Katie Childers.)

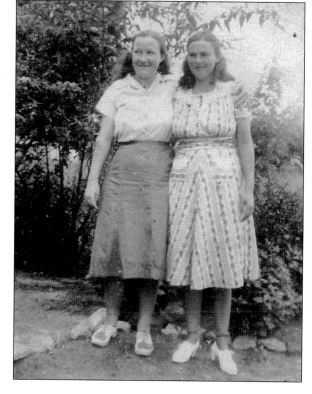

Many friendships that were made on the hill lasted a lifetime. Hettie Rudisill was a very good neighbor. When Katie Childers went to work at 2:00 and left clothes on the line, Hettie would take the clothes in and water the flowers. Virginia Edwards, left, poses with Hettie. They often canned food together and would sit and talk for hours. (Courtesy of Anita Brittain.)

Fred Hudson, center, lived with his wife, Lula, in a house across from the Company Store. On Saturday nights, the Hudsons witnessed large groups congregating in front of the Company Store. Drinking, cursing, fighting, and shooting were standard among the crowds. People often came from outside of Henry River to join in the debauchery, and it is said that the outsiders caused the most trouble. (Courtesy of Howard Hudson.)

In the boardinghouse lived, from left to right, (first row) Annie Propst Raby Bolick and Carley Raby Bollinger; (second row) Margaret Bolick, Janette "Tiny" Raby Roper, and Ola Raby Hudson. Each floor of the boardinghouse had two two-room apartments and two single rooms for those who only needed a bedroom. Residents often prepared meals together in order to economize and socialize. (Courtesy of Janie Green.)

Charlie Young, left, kept his prized watermelons on his porch, warning that whoever stole them would be in trouble. This did not stop Gary Lynn, Doug Reep, Ricky Hames, and Ray Burns. Waiting until dark, Ray crawled to the house and grabbed the biggest watermelon, handing it to another boy who dropped it. About to get caught, the boys ran down Dog Trot into a dark hollow. (Courtesy of Glenda Young.)

Mel Newton's granny, Kate Lynn, raised hogs for ham and sausage. While Mel was serving in the armed forces, Kate mailed him jars of canned sausage. Mel and the mess cook shared a midnight feast of sausage, eggs, biscuits, and gravy. The sausages fared far better than the Moon-and-Star watermelon that Granny Kate also shipped from Henry River to Korea. Here, with Steve Burns, right, young Mel, holding the gun, seems to be practicing for war. (Courtesy of Mel Newton.)

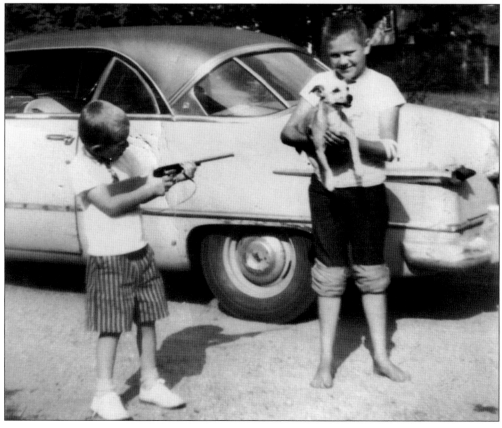

Because living rooms, like the one seen here, were so small, village women often hung their quilting frames from the ceiling. Since the bedrooms were so cold, the making of these quilts was essential. Most people used bottom sheets, if they had them, and covered up with patchwork quilts. Scraps of fabric leftover from dresses were sewn together by hand or by a pedal sewing machine for the tops of quilts. (Courtesy of Patsy Burns.)

Like many residents on the hill, Frank and Lillie (pictured here) Bollinger kept a milk cow, hogs, and chickens. Hogs were salt-cured or canned, chickens supplied eggs and Sunday dinner, and grease was used to make lye soap. Animal food was purchased in 100-pound floral-print sacks, the fabric of which was later used to make dresses. Villagers were industrious, making full use of every item they encountered. (Courtesy of Janie Green.)

Maude Lowman, left, and Elizabeth Raby rest in front of the winter's wood, which has been packed beneath the house. When the weather cooled, it took two men to cut down trees with a five-foot-long manual crisscross saw. The wood was then cut into lengths and split by hand with an axe. Large pieces provided fuel for the fireplace or wood heater, with smaller ones for the kitchen stove. (Courtesy of Brenda Lowman.)

On laundry day, water was carried from the pump to fill three tubs. Clothes were scrubbed by hand on a washboard and then boiled in a cast-iron pot kept hot with a wood fire. With the use of a broomstick, clothes were then moved to rinse tubs and hand-squeezed before being hung on the line. In order to press, flat irons were heated on the wood stove. (Courtesy of Ruby Keller.)

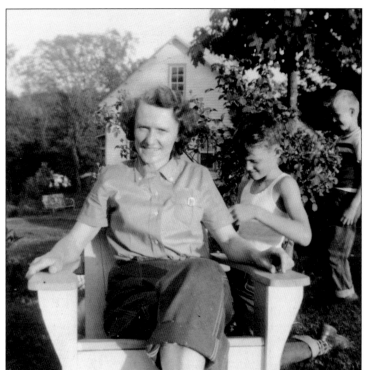

Ruby Fleming, left, and her husband, Weaver, raised four sons on the hill: David; Roger, center; Phil, right; and Steve. When Richard Hefner lost his mother, Maxine Newton, in a 1959 automobile/train accident, he remembers the kindness of Ruby, who made certain he never went hungry. All these years later, Richard still recalls that there was nothing better than Ruby's peanut butter and sugar sandwiches. (Courtesy of Ray Burns.)

A.C. Bollinger, right, remembers his daddy, Frank, hitching their horse, Betsy, to a wagon and the family riding to the farm to pick blackberries. When the new bridge was built across Henry River, Nanny, Minnie, and Mandy Lail's house was in the way. It was torn down and given to Frank, who moved it to the farm. The Lail sisters were relocated. (Courtesy of Janie Green.)

Although a few very lucky children owned bicycles, adults were far more likely to have them. Because of limited resources, bicycles were a means of travel as well as pleasure. Here, Margaret Lowman Smith (left) and Mildred Lowman Speagle proudly pose on their bicycle, ready, it seems, for an afternoon spin. (Courtesy of David Smith.)

Roby Powell must have had a lot of cheer in his eyes when he missed the old Henry River Bridge. Here, his car hangs over the railing, barely missing the long drop to the river below. Back in the "good old days," if a person were drunk, the sheriff would pour out the hard-earned whiskey before sending him on his way home. (Courtesy of Ray Burns.)

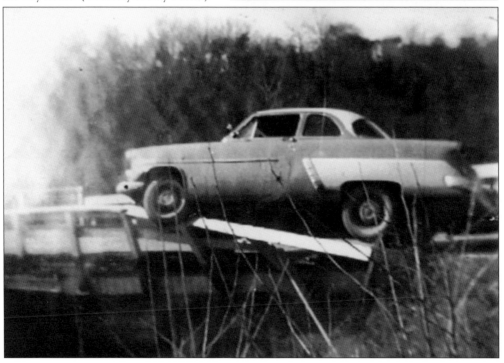

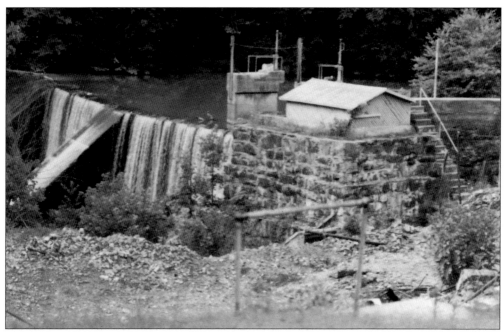

Every five or so years, the dam would have to be "drawn off," meaning that the gates would be opened so men could clear out mud. "Drawing Off" was a big event on the hill. Once the water was out, residents rolled up their overall legs and waded into the mud to fill buckets with fish. For many nights to follow, villagers feasted on free fish. (Courtesy of Paul Pope.)

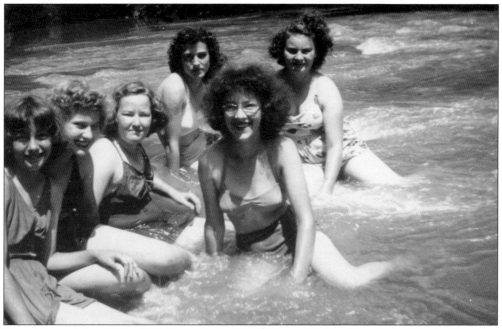

From left to right, Jackie Hildebran Austin, Ruby Young Keller, Susie Raby Hamby, Blanche Newton Hames, Verlene Hildebran Hicks, and Mabel Cline Hudson relax in the shallow water down near the old bridge. Cooling off and getting clean provided the luxury of not having to carry water for a sponge bath in the evenings. (Courtesy of Ruby Keller.)

Because there were only oil lamps, most people went to bed at dark. When electricity finally came, Ruby Young Keller remembers the 40-watt bulb hanging in the middle of the ceiling as the brightest in her memory. For entertainment, villagers often sat on their front porches listening to each other play music. By the time night fell, people returned home to their unlocked houses. (Courtesy of Ruby Keller.)

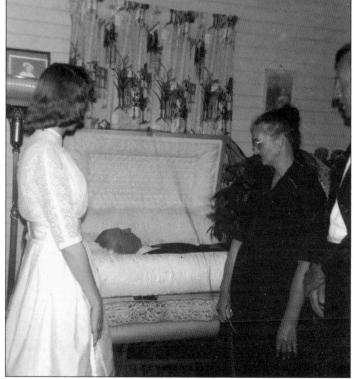

On the passing of a family member, furniture was moved from the living room. The day before the funeral, the body was returned to the family to spend a final day at home. Wakes were held, and neighbors sat with the body through the night. The following morning, flowers displayed in the room were carried by "flower girls" from the house to the church. (Courtesy of Mel Newton.)

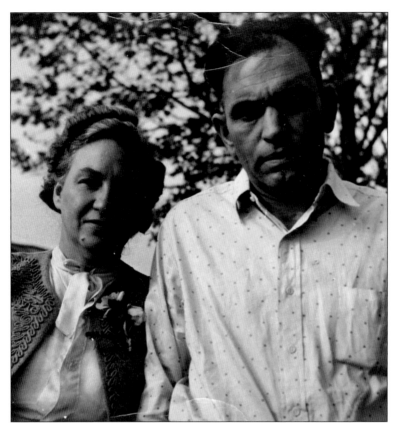

Like everyone in the village, Rose and Ed Cline's address was simply Henry River, North Carolina, and was delivered to wooden boxes in the Company Store. The house numbers sometimes referred to did not exist until after the village was deserted when David Smith drew a map of the village and assigned each house a number. Ed served as first-shift supervisor of spinning, spooling, and winding. (Courtesy of Adam Willis.)

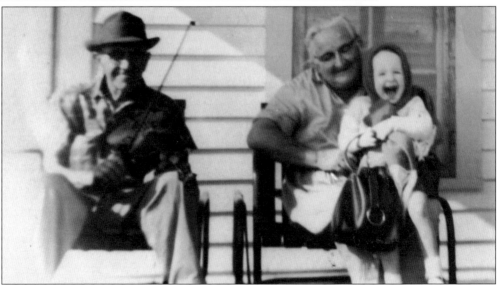

Sitting on their front porch, Frank and Lillie Bollinger entertain their granddaughter with fiddle music. Frank did not let the fact that he had only two fingers on his right hand stop him from playing "Whoa, Mule, Whoa," his grandchildren's favorite tune. Besides working in the mill, Frank drove his old Dodge truck to the Aderholdts' home to milk their cows twice a day. (Courtesy of Larry Robinson.)

Many girls on the hill married young. At age 14, Linda Cline sneaked away with her sweetheart, Toby Young, to marry in South Carolina where the laws were not as strict. The couple moved into a house across from the store and had three children, Gail, Michael, and Robin, before divorcing 35 years later. (Courtesy of Frances Beckom.)

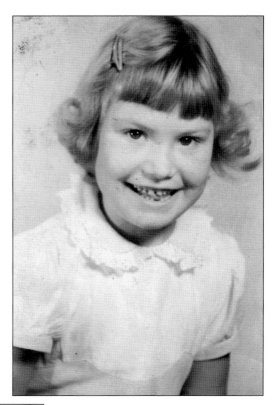

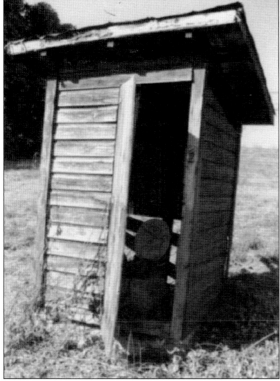

All village houses had outside toilets. Although some residents had slop jars, they were rarely used except in the coldest times of the year. When a toilet hole reached maximum capacity, a new hole was dug and its dirt was used to fill the old hole. In one of the worst jobs at the time, the company paid a man who lived nearby to clean out toilet holes. (Courtesy of Richard Hefner.)

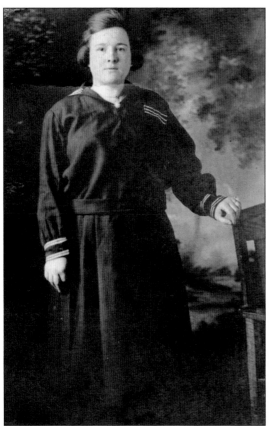

During the Depression, Diane Eckard's grandmother, Wilma Cline, pictured, began working in the mill. Diane's husband, Frank, came to the hill with his uncle, John David Rudisill, to sell milk. Before the milk was sold to villagers, cream was skimmed off the top and kept by Miles Rudisill's family. Villagers called the milk "Blue John" because, with all the cream gone, the weak milk had a bluish tint. (Courtesy of Diane Eckard.)

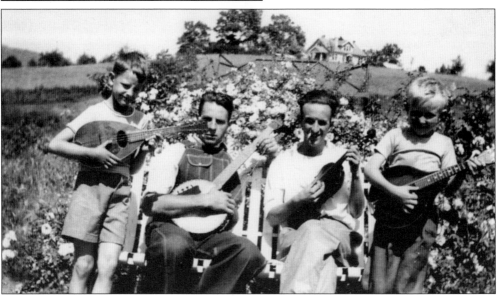

From left to right, Ralph Pope, Sam Pope, Alvin Bollinger, and Bobby Bollinger enjoy a summer afternoon playing country music in the backyard of Frank Bollinger's house. In the background are the ball field and the Moose house. Frank Moose was married to Lula, one of the Aderholdt sisters, and helped build the mill. (Courtesy of Larry Robinson.)

Whether it was Henry River magic or plain old love at first sight, people on the hill were a little shocked when Margaret Stillwell came to work in Henry River Mill, met Leroy Burns, and married him within two weeks. They lived in the hill, raised three children, and were together until death. (Courtesy of Ray Burns.)

For years, Tom Cline (below) worked in the opening room, and his wife, Mary, was a spinner. Like all mill hill residents, they did not have a telephone. If a call needed to be made, the only phone available was at the Company Store. If someone needed emergency care, they were taken by car. In extreme situations, workers went to Miles Aderholdt's house to make calls. (Courtesy of Ruby Keller.)

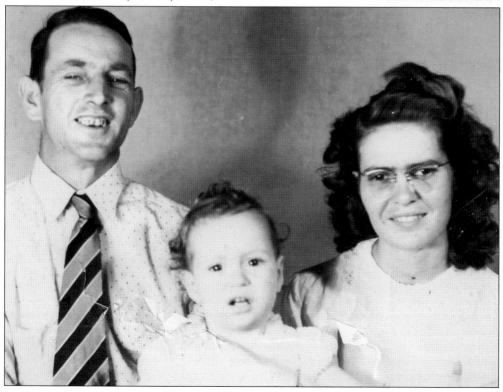

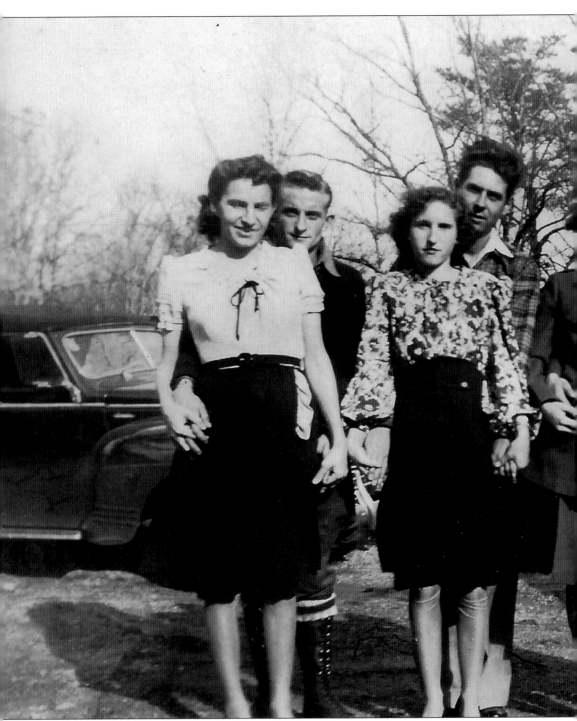

Maude Lowman worked in the mill where her husband, Dorse, was a fixer. They raised their children in house No. 6, but sadly, Dorse passed away before their youngest daughter, Ruby, was grown. Because Miles Aderholt would not allow two people to live in a four-room house, Maude and Ruby were forced to move into the boardinghouse. This rule affected many young couples as

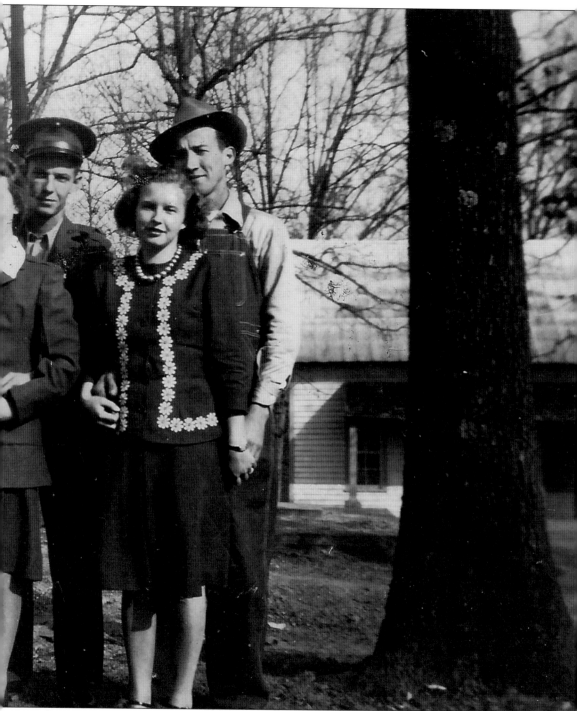

well. From left to right, standing in the Henry River sun, are some of those young couples: Sallie Smith Lowman, Clinton Lowman, Margaret Lowman Smith, Charlie Smith, Mildred Zimmerman, Grady Lowman, Mildred Lowman Speagle, and Walt Speagle. (Courtesy of David Smith.)

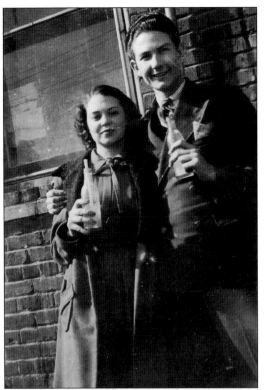

Around 1935, Irene Duckett and her father, Sam, enjoy a soft drink. Sam worked in the mill and was also the father of Leroy and Vivian. Many in Henry River had a difficult time dealing with Vivian's death in 1938, when, at the age of 20, a car with its lights off, trying to elude the police, struck the car she was riding in. (Courtesy of Vernon Duckett.)

Because there were certainly no restaurants in the village, "eating out" meant walking into the backyard with a tomato sandwich. Like children, adults were forced to find their own entertainment. Here, a cookout takes place in the woods on the other side of the river. Enjoying the night are, from left to right, Marie Lynn, Evelyn Newton, Ruby Lowman Young with Junior Young behind her, Joe Hefner, John Henry Young, Hazel Young, and Melvin Newton. (Courtesy of Mel Newton.)

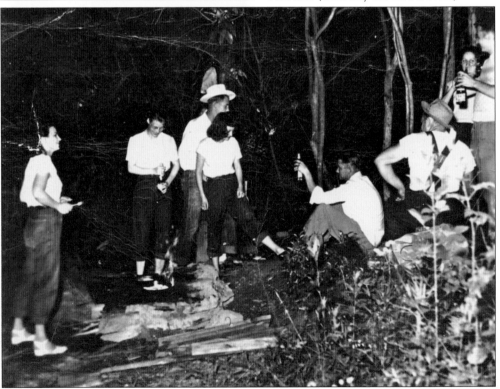

Walter Young built his own incubator to raise chickens for food. Once they were big enough, chickens were kept in a lot behind the house. When they wanted chicken for dinner, Walter's wife, Martha, would have to chase the chicken, catch it, hold it by its head, and wring its neck. It was then scalded and singed over an outside fire before being cooked. (Courtesy of Ruby Keller.)

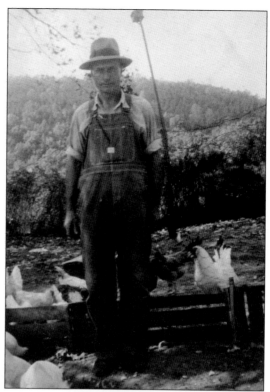

Despite being blind in one eye because of a childhood accident, Margie Burns worked in the mill and met her husband, Jay Brittain, there. Once married, they moved into two rooms of the four-room house where her brother Leroy lived, but then moved to the boardinghouse when Leroy started a family and needed all four rooms. Here, Margie and Jay relax with their son Paul. (Courtesy of Pam Adams.)

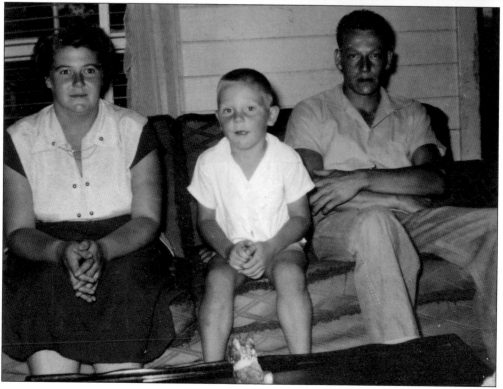

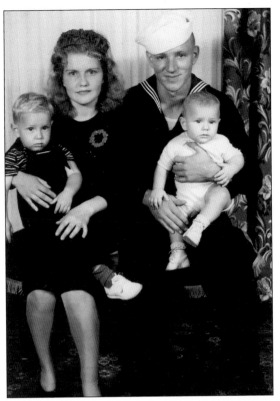

On December 7, 1941, Japan bombed Pearl Harbor, and changes came to Henry River. The little village sent 37 men to the armed forces during the war; two of them were killed. Many women like Myrtle Gilbert became single mothers for several years. In a moment of reprieve, Myrtle sits with her husband, David, and sons Allen and Jerry. (Courtesy of Ruby Keller.)

Ration stamp books were numbered from one to four and were issued in both adult and children's names. Strict rules were listed on the backs of books, and although it was against the law, some people sold their stamps. Merchants were told what to charge for merchandise, but some sold hard-to-get items on the "black market" for high prices. (Courtesy of Adam Willis.)

INSTRUCTIONS

1 This book is valuable. Do not lose it.

2 Each stamp authorizes you to purchase rationed goods in the quantities and at the times designated by the Office of Price Administration. Without the stamps you will be unable to purchase those goods.

3 Detailed instructions concerning the use of the book and the stamps will be issued from time to time. Watch for those instructions so that you will know how to use your book and stamps.

4 Do not tear out stamps except at the time of purchase and in the presence of the storekeeper, his employee, or a person authorized by him to make delivery.

5 Do not throw this book away when all of the stamps have been used, or when the time for their use has expired. You may be required to present this book when you apply for subsequent books.

Rationing is a vital part of your country's war effort. This book is your Government's guarantee of your fair share of goods made scarce by war, to which the stamps contained herein will be assigned as the need arises.

Any attempt to violate the rules is an effort to deny someone his share and will create hardship and discontent.

Such action, like treason, helps the enemy.

Give your whole support to rationing and thereby conserve our vital goods. Be guided by the rule:

"If you don't need it, DON'T BUY IT."

☆ U. S. GOVERNMENT PRINTING OFFICE: 1942 16—30855-1

During the course of World War II, the government issued ration stamps for almost everything. Coffee, sugar, tea, and shoes were all rationed items, while other items, such as automobile tires, could not be purchased at all. Villagers relied on each other more than ever to try to make their lives as comfortable as possible. (Courtesy of Adam Willis.)

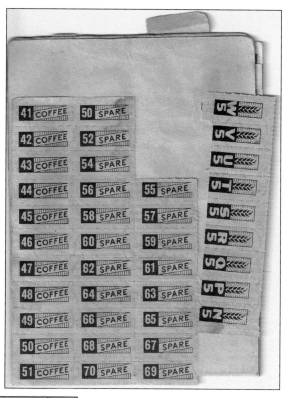

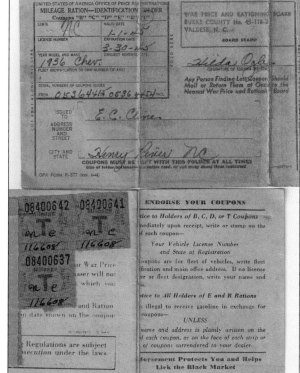

Because of North Carolina's proximity to the coast, villagers lived in fear of being attacked. At night, the company conducted air-raid drills. Car horns were blasted at the top of the hill, mandating a complete blackout. By day, villagers were frugal. Issued to Ed Cline, this gasoline stamp book contains a few stamps left after the war. (Courtesy of Adam Willis.)

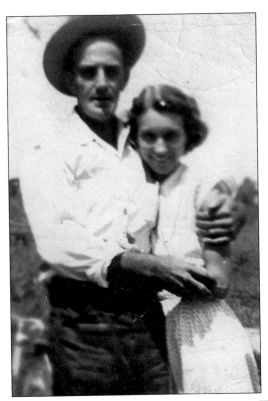

Sally and Cordell Hildebran moved in and out of Henry River multiple times. Their daughter Verlene recalls that her mother told her that she was so hard on shoes during the war that they had to use everyone in town's ration stamps to keep her feet off the ground. Residents often had their shoes half-soled to stretch the amount of wear they got from each pair. (Courtesy of Verlene Hicks.)

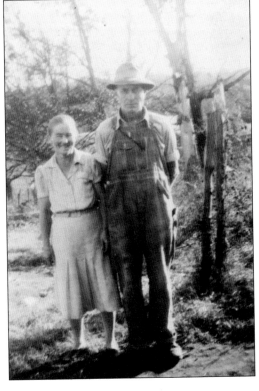

During the war, when Walter Young fell in the mill and hurt his back, he was told by doctors that he would have to travel to Winston for surgery. Since the tires on Walter's car were completely worn out, fellow villagers took tires off their own cars and put them on Walter's; others donated gasoline ration stamps. Community kindness enabled Walter to get to the hospital. (Courtesy of Ruby Keller.)

Four

PRAYING HARD

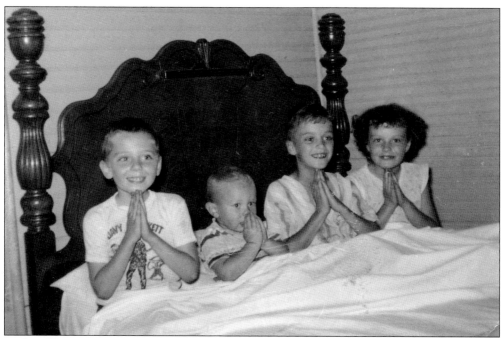

In the village, it was custom for three beds to be squeezed into one room where the entire family slept. Here, from left to right, Doug Reep, Mel Newton, Ricky Hames, and Sherry Newton recite the bedtime prayer of children the world over: "Now I lay me down to sleep / I pray my Lord my soul to keep / If I die before I wake / I pray my Lord my soul to take." (Courtesy of Mel Newton.)

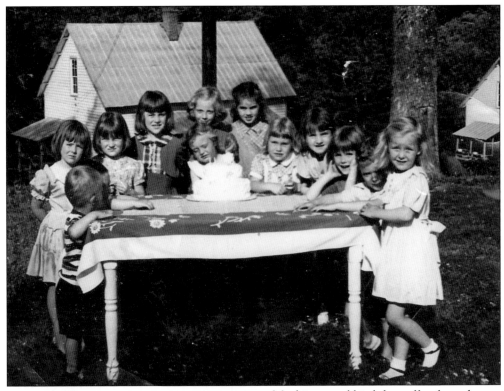

Mealtimes and birthdays offered another opportunity for prayer for children in Henry River. Here, celebrating Sherry Newton's birthday, several children eagerly await the cake. First, though, they will have to pray: "God is great / God is good / Let us thank him for this food / By his hands we all are fed / Give us Lord our daily bread. Amen! P.S. Thanks for the cake!" (Courtesy of Sherry Wilson.)

Religious services were often held in the big center room upstairs in the boardinghouse. Preachers of the gospel sometimes came from as far as West Virginia to preach the Word of God. Villagers provided room and board during these visits. Pictured in the lawn behind the boardinghouse is Sue Raby. (Courtesy of Ray Burns.)

Henry, left, and Texie Buff lived and worked in Henry River during the Depression, surviving on beans and potatoes. Their son Virgil remembers wearing shoes with holes in the bottom even in the snow. Although Henry never drew a paycheck because he owed the Company Store, he believed in subsisting on the spirit and could often be seen preaching in front of the Company Store. (Courtesy of Virgil Buff.)

Rev. Jack Holland baptized Betty Lynn at Rhodhiss Beach. Diane Eckard remembers thinking that her mother was wasting a lot of time starching and ironing her dress before walking into the river. Betty explained that she simply "wanted to look good for the Lord." (Courtesy of Diane Eckard.)

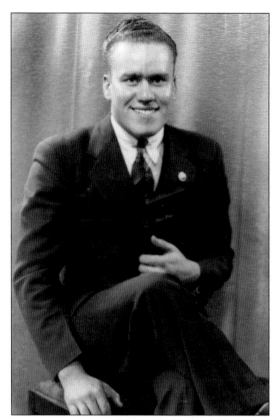

In the summer of 1940, three young men drove down the hill and into the mill village. A loudspeaker on top of the car announced news of worship services to take place under the trees beside Tom's Store. One of these men was J.T. Cline, pictured at left, who many believe "brought religion" to Henry River. That first summer, the meetings were held outside and garnered a faithful following. When cold settled in, believers moved into the home of Tom Townsend. Villagers cut wood and carried it a quarter of a mile to heat the house for services. In October of that same year, surrounded by a loyal 75-member congregation, still in the Townsend living room, Cline officially organized the Henry River Baptist Church, thus providing the villagers with a permanent worshipping home. (Both, courtesy of Katie Childers.)

Hymns often spilled over into the streets of Henry River. One of these hymns still echoes: "Precious memories how they linger ever near me." The first summer after J.T. Cline (to villagers he was never Reverend Cline but their "friend J.T.") came to Henry River, the young people of the church felt he needed a suit, seen at right, so they picked and sold enough blackberries to purchase one for him. (Courtesy of Katie Childers.)

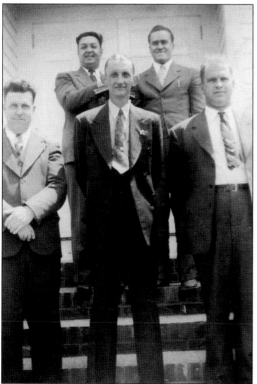

In February 1941, recognizing the need for a more permanent dwelling, a building fund committee from the congregation gathered 25¢ and 50¢ donations and paid Tom Townsend $150 for an acre of land. Conducted by Frye Construction, building began immediately. Bill Smart and Raymond Burns made the pews. On May 11, dedication services were held, and the congregation moved into what would become their longtime home. (Courtesy of Katie Childers.)

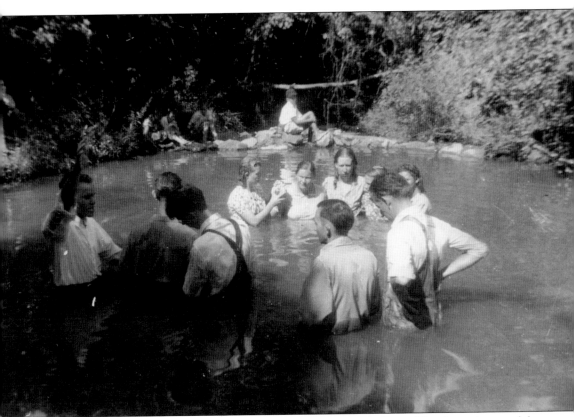

Hymns flooded the streets and drifted their way down to Henry River. The first minutes of the new church were recorded on December 1, 1940. That day, it was agreed upon to hold the first of many baptismal services on December 14, 1940. It seems even the winter cold could not keep villagers from their Lord. Here, waist-deep in Henry River, believers await their turn for baptism. This December date fell before the ground was even broken for the building of the church, showing that matters of the spirit were indeed more important than matters of the flesh. (Courtesy of Ruby Keller.)

The dedication service on that May day drew believers from far and wide. A long table of food was provided by the villagers to be enjoyed by all. Here, hungry after the long service, Rev. J.T. Cline (left) stands with supporters Rev. Jeter Poarch (center) and Rev. Grady Hamby (right), looking forward to the meal in front of them. (Courtesy of Katie Childers.)

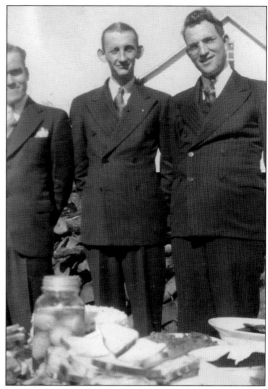

In Henry River, church started early on Sunday mornings with Sunday school and was followed by a long sermon from J.T. Cline. Afterwards, church members provided a large outside dinner, which allowed the community to come together. In early evening, churchgoers returned for prayer meetings and more preaching. Because many on the hill were hard-shell Baptists, they considered shorts, makeup, and movies as sinful. (Courtesy of Ruby Keller.)

When homecoming was planned, J.T. Cline set a goal of 200 to attend. Walter Young hitched his horse "Old Joe" and took him to the church. After the service, Cline stood at the doorway, shaking hands and counting heads. When the last person passed through, Cline was disappointed to have only counted 199. Finally, he looked up and saw Old Joe who became No. 200. (Courtesy of Katie Childers.)

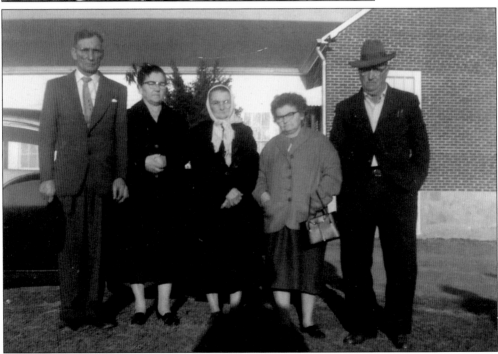

Death often brought families together at Henry River Church. Attending the funeral of their sister Julie Robinson Young are, from left to right, William Robinson, Martha Robinson Young, Belle Robinson Burns, Lizzie Robinson Hanby, and Eli Robinson. In April 1951, land on the hill behind the church was purchased from the Henry River Manufacturing Company to be used as a graveyard. Many families from the mill hill are buried here. (Courtesy of Ruby Keller.)

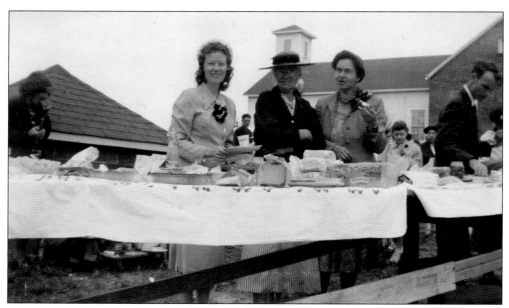

From left to right, Nancy Mayes, Minnie Herman, Carrie Herman Smart, and Rev. Lamont Mayes pile their plates high during a big dinner out behind the church. Village women brought covered dishes, and fried chicken and potato salad were always favorites. Mayes served as pastor of the Henry River Church from 1953 until 1966. (Courtesy of Ray Burns.)

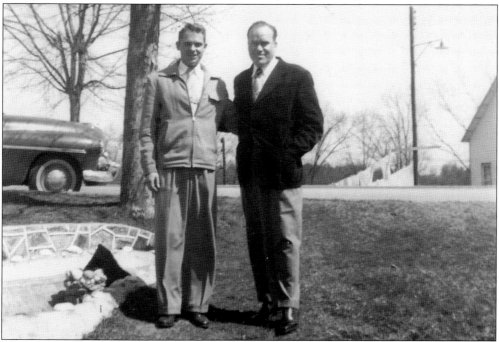

"As I travel on life's pathway," as an old hymn goes, "I know not what the years may hold." With prayers and determination, J.T. Cline saw the Henry River Church rise from the ground and prosper. Cline served as pastor for five years before feeling "called" elsewhere. Over the years, Cline stayed in touch with his first congregation and often returned to the hill to preach funerals. (Courtesy of Ruby Keller.)

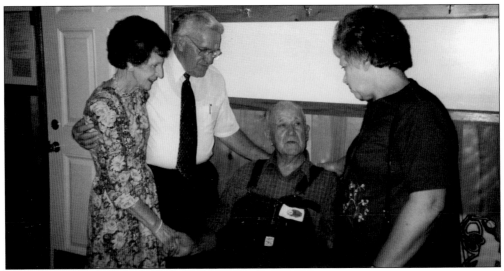

Many villagers considered J.T. Cline, second from left, their preacher even after he left Henry River. Here, Cline's wife, Billie Sue (left), and their daughter Elaine visit Henry River for the 90th birthday of longtime resident Bud Rudisill. This was J.T.'s final visit to a mill house before his death in 2011. (Courtesy of Anita Brittain.)

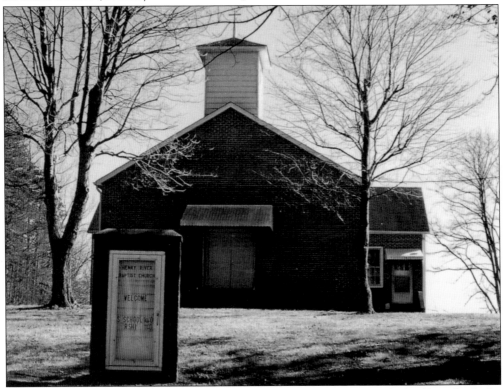

As a memorial to mill workers who made 25¢ and 50¢ contributions to the building fund, the Henry River Church still stands today. Records show that at least one person from every house in the village was, at one time, connected to the church. In fact, many former villagers still attend the worship services held in the church. (Courtesy of Anita Brittain.)

Five

GROWING UP ON THE HILL

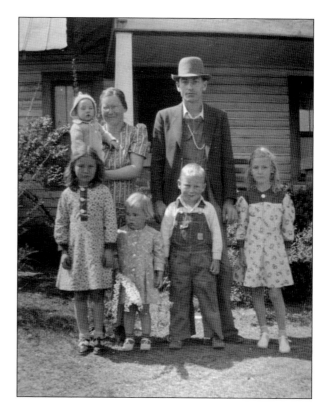

Up until the 1930s, mattress-size bags were filled with straw and placed on wooden slats on full-size iron beds. When ticks were first filled, they were tall and puffy, and children made a party of jumping on them. Standing in their front yard are the Clines, from left to right (first row), Mabel, Helen, Harold, and Betty; (second row) Frances, Bessie, and Bill. (Courtesy of Frances Beckom.)

Many children in the village received either nothing or a small box of chocolate-covered cherries for Christmas. One Christmas, Doug Reep, right, was fortunate enough to receive a BB gun. He immediately rushed outside to try it. Shortly after, he ran back in crying, "Mama, I killed Mrs. Lillie Bollinger's rooster!" The joy of the BB gun diminished when he had to apologize to Lillie. (Courtesy of Susie Childers.)

At 13, Max Johnson, right, who delivered papers in Henry River, became interested in girls but was embarrassed by warts on his hands. His mother, Jewell, suggested he walk across the bridge to see Kate Lynn, who was rumored to have healing powers. Although skeptical, Max went to see Kate, who rubbed his hands and mumbled some words. A few weeks later, the warts had disappeared. (Courtesy of Laura Newton.)

Melvin Newton, whose older sister Ruby helped him get ready for school, once boarded the bus with soap still in his hair, earning him the lifelong nickname "Soapy." Soapy remembers shoes were resoled until the tops wore out. He tells of being a boy and going to the shoe shop with his daddy, Frank, where he sat on a stool until his shoes got new bottoms. (Courtesy of Evelyn Newton.)

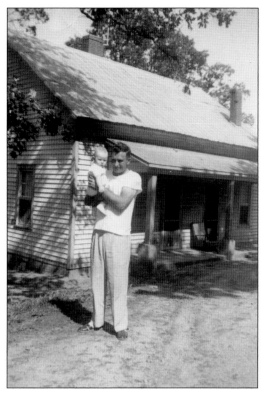

A photograph arrived in Henry River with the following caption: "Hey Aunt Kate, it's me and my cat in Edgefield, South Carolina." Soon after this, Alvin Young, his family, and his cat returned to live in Henry River, where Alvin eventually worked in the mill until going back to college and becoming a pastor. People often left Henry River, but many of them returned shortly after. (Courtesy of Melvin Newton.)

Being dared to do so, Clinton Lowman, pictured, and Eli Young would walk across the tops of the angled iron railing on the sides of the old Henry River Bridge. The bridge was said by some to be the "scariest bridge in the world," but nothing could scare the young daredevils of the village. (Courtesy of Clinton Lowman.)

Between the trash dump and the river lay a deep red gully. Billy Joe Newton, pictured, and some other boys tied knots in the end of a rope and threw it over a tree limb. One summer day, they dared Polly Floyd Smith to swing over the hole then loosened the rope and let her fall. They had to work a long time to get her out. (Courtesy of Laura Newton.)

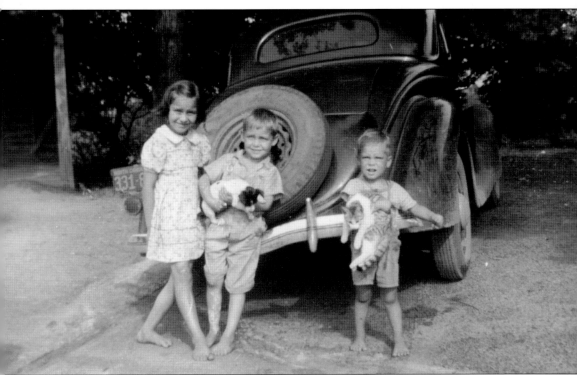

Tony Lynn, center, started his first business when he was 10 years old. He borrowed $139 to purchase a lawn mower. In his first year in business, he was able to pay the small fortune back. The following year, however, Tony faced fierce competition because someone else bought a better mower than his and was willing to work longer, harder hours. Tony says that he had a few loyal customers who stuck by him, but ultimately, his first business failed. In later years, Tony was more successful. He worked in management for various financial institutions and began his own leather business, selling goods to furniture and car manufacturers. Here, Tony stands barefooted with siblings Scotty, left, and Mickey Lynn (right). The pets in the photograph give a brief glimpse into the domesticated animals that also made their homes on the hill. (Courtesy of Tony Lynn.)

J.D. Lynn, right, was born in 1927 with a hole in his chest large enough to fit a person's fist. At the time, there was nothing that could be done for a person with this condition. He lived to be 18 years of age. Here, during his brief life, he enjoys a bicycle ride with good friend Tate Pope Jr. (Courtesy of Gary Lynn.)

Tony Lynn, pictured; Harold Cline; and Richard Young often played ball in the village and then headed for the dam. There, they scaled the moss-slick dam and climbed steep pillars. Tony recalls that once he was climbing and started to slip but was saved by a prayer. The river trip served as a daily bath and a way to cool off before heading home to a hot house. (Courtesy of Tony Lynn.)

Before electricity, residents used iceboxes to keep food fresh. Paul Pope, center, remembers the ice truck coming from Sherrill Ice and Fuel. Each house hung a sign out front with the amount of ice they desired, and the iceman chipped that amount from a huge block and then carried it inside with tongs. Children often followed the truck hoping to receive loose pieces of ice. (Courtesy of Paul Pope.)

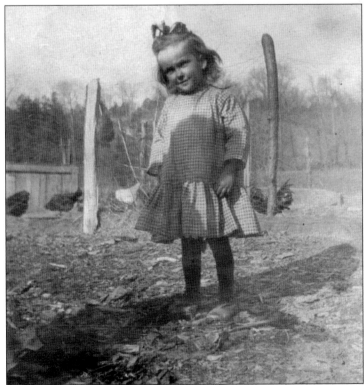

Annie Mae Cline was born deaf and was unable to speak. She attended the Morganton School for the Deaf where she learned to sign. Eventually, she also became blind from diabetes. This, however, did not stop her from communicating. In her later years, Annie Mae would cup her hands on the face of the speaker and know what they were saying. (Courtesy of Diane Eckard.)

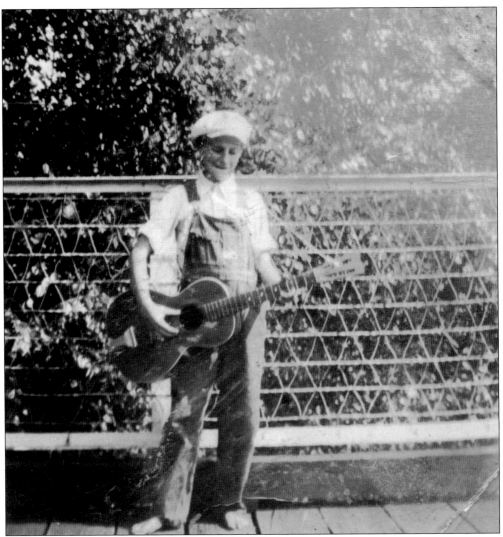

Barefoot on the old bridge, Henry Johnson strums his guitar. In Henry River, being barefoot was a savored state of being for some folks. Many adults stripped off their shoes when they got a chance, and others went shoeless to save their soles or because they had no choice. Come summertime, all the children of the village went barefoot. Some were allowed to shed their shoes as early as March or April, but others were forced to wait until May. On May 1, no matter how chilly it was, children ran outside to put their bare feet onto the cold, hard ground. (Courtesy of Anita Brittain.)

In 1959, Harold Cline had just started driving and wanted to see how fast his daddy's 1957 Chevy would go. He gunned up Miles Aderholdt's long, circular driveway, right past the front door, and reaching the end of the driveway, hit a curb and destroyed the car. Though he was not hurt, he had a lot of explaining to do when he got home. (Courtesy of Frances Beckom.)

Like most residents, Paul Pope, left, learned at a young age to work for the things he wanted. At age 12, he made 50¢ a week helping his uncle, J.D. Young, split wood. On Saturdays, he caught the bus to Hickory for a dime, went to the movies, bought popcorn and a drink, and still had a dime left for the bus ride back. (Courtesy of Paul Pope.)

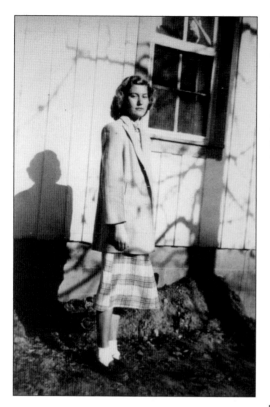

New drivers often "practiced" driving on the roads around the village. Helen Toonse Cline, on her way to pick up her mother, Bessie, at the 2:00 p.m. shift change, caused quite an excitement when she attempted to turn between the rock wall and the cotton house. Missing the driveway, she went over the wall in her daddy Bill's 1948 Chevy. To everyone's relief, she exited uninjured. (Courtesy of Frances Beckom.)

Louise Pope Brittain's father, Andy, never received money on payday because he charged at the Company Store. Once a person got into debt with the store, it was almost impossible to get out. With her family, Louise remembers living in a four-room house and being told to move into just two rooms so that the company could rent out the remainder to another family. (Courtesy of Louise Brittain.)

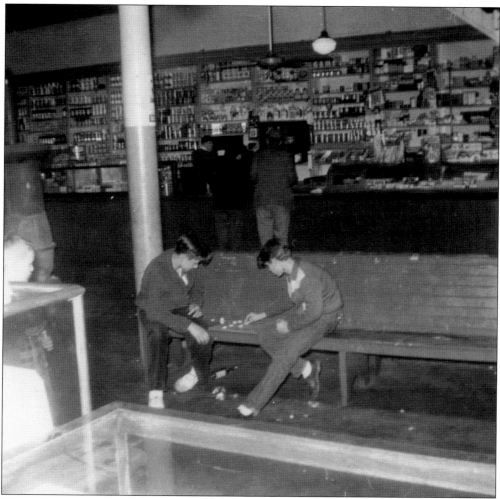

In March 1958, Herb Liverett (left) and Johnny Pope (right) enjoy a game of checkers on one of the long benches in the Company Store. Men and boys often spent hours here enjoying games on homemade checkerboards. Soft drink bottle caps were used as checkers. Soft drinks, or "dopes," as they were called, were stored in metal boxes with lids that lifted and came in glass bottles for which a deposit was paid. To get another without a deposit, one simply returned the bottle. In the background, two men pick up essentials. Mailboxes were also kept behind the counter. (Courtesy of Ruby Keller.)

When Eli Young was six years old and living in South Carolina, his daddy, Walter, purchased a new Ford Coupe with snap-on windows. The good life was, however, short lived. When the Depression came, the Youngs began the trip back to house No. 4 in Henry River. Eli, Myrtle, Katie, and Alvin were in the back under a lap robe, and the milk cow rode in a small trailer. (Courtesy of Ruby Keller.)

When Verlene Hildebran Hicks was just 14, she babysat Doug and Susie Reep who lived in the boardinghouse with their mother, Margaret. One evening when a big spider showed up on the floor, Verlene jumped up on the bed and told Susie to kill the spider. Residents joke that sometimes it was hard to tell which child in the group was the designated babysitter. (Courtesy of Verlene Hicks.)

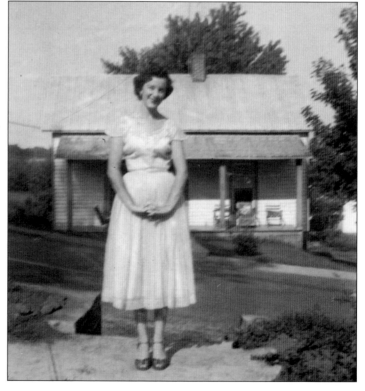

On her ninth birthday, Pam Brittain decided to have a birthday party. Riding home from school, she invited all of the children on the bus over to her house. When her mother, Margie, came home from work, she found a house full of children waiting for cake. Since the party was a surprise to Margie, she had to rush to the store for treats. (Courtesy of Pam Adams.)

At Christmastime, each child who had been "good" received a dollar from the company. One year, Vernon Duckett did not receive a dollar and became angry. He gathered a bucketful of rocks and threw them until he had broken every window in the Company Store. Perhaps, the company would have saved a lot of time and trouble had it given every child a dollar. (Courtesy of Vernon Duckett.)

Although Jackie Hildebran Austin (pictured), Verlene Hildebran Hicks, and Ponee Hildebran Buchannan were happy children in Henry River, they decided that it was time to run away to Hollywood. After considerable planning, they each put a toothbrush and toothpaste into a paper bag and started walking. They made it across the long Henry River Bridge and onto the lonely dirt road before deciding to return home. (Courtesy of Verlene Hicks.)

With very few store-bought toys, children had to be creative; stick guns and broomstick horses made for a good afternoon of cowboys and Indians. As girls, the Rudisills, Faye (left), Anita (right); and Nadine, received a single bicycle to share. As teens, they shared one car. Residents often did not have much but were grateful for what they had because they knew many had even less. (Courtesy of Anita Brittain.)

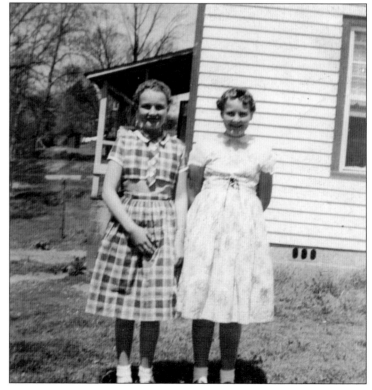

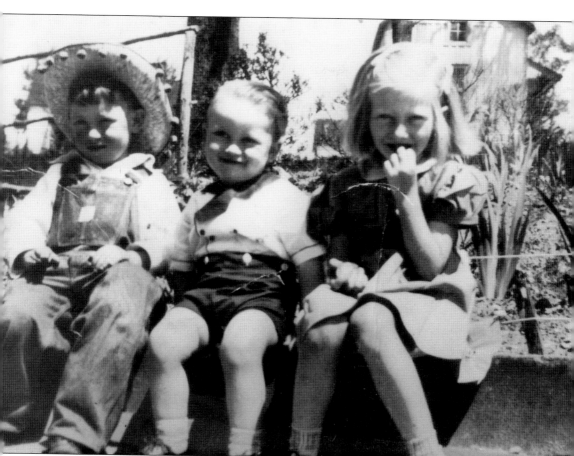

As children, Jim Rudisill (left), Larry Hudson (center), and Jean Hudson (right) were rarely seen without each other and loved to seek out adventures. Their favorite game was hiding from their mothers. As they grew older, the woods and river became their playground. When she found out that he had been playing at the river, Larry's mother, Lula, declared, "Larry, you can't go swimming until you learn how to swim." Little did she know that the three had been swimming for a long time. Here, the three children look unusually well behaved, but, as usual, there is a glimmer of mischief in their eyes. (Courtesy of Anita Brittain.)

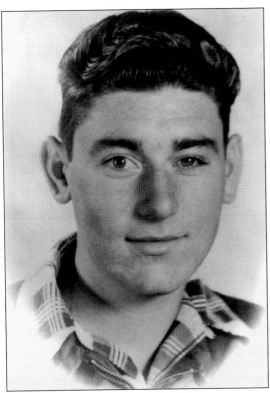

By placing a button on a string, looping an end over each hand, and twisting the string until it was taut, Jimmy Rudisill created a toy. Unfortunately, one day, the button misfired and flew into Jimmy's eye. Because the family did not own a car, Jimmy was not taken to the hospital until the following day. He lost an eye and spent weeks in the hospital. (Courtesy of Anita Brittain.)

Anita Rudisill Brittain, center, remembers her daddy, Bud, getting her, Nadine (left), and Faye (right) up at 4:00 in the morning to check "cooter" hooks in the river. Cooters were red-bellied turtles that sometimes provided food for residents of the village. It was said that cooters came in seven different flavors of meat. They could also be caught by feeling for "cooter holes" in the mud. (Courtesy of Anita Brittain.)

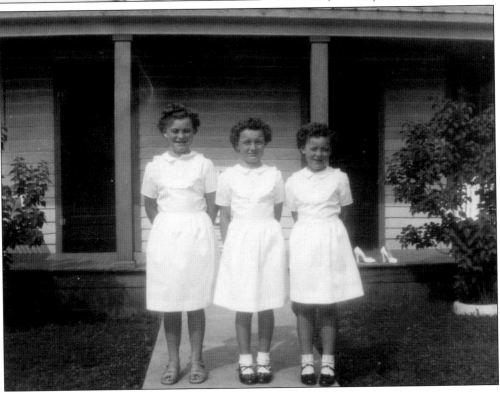

Even the smallest children wanted to fish in the river. One hot summer afternoon, Ernie Burns, pictured, and his brother Steve stood on chairs at the reservoir fence to catch carp. Losing his balance, perhaps for a big ole catch, Steve fell onto the fence and required 24 stitches for his cuts. (Courtesy of Steve Burns.)

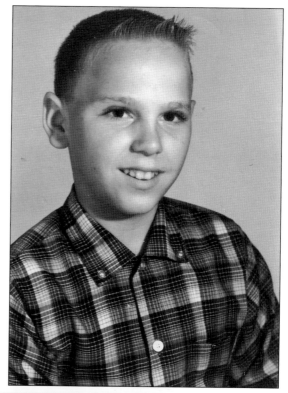

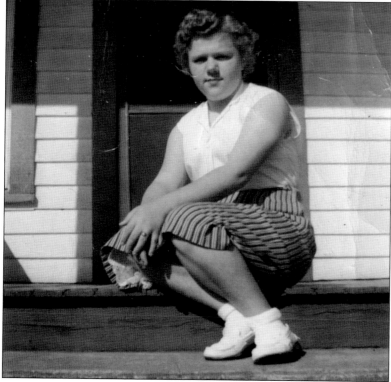

Brenda Burns was sent to the Company Store one day to purchase Epsom salts. Afraid she would forget what she was asking for, she repeated "Epsom salts" to herself on the way to the store. When she arrived, Edward Childers looked down at her and asked what she wanted. "I want a box of exposing salts," she told him. Fortunately, he knew what she really needed. (Courtesy of Steve Burns.)

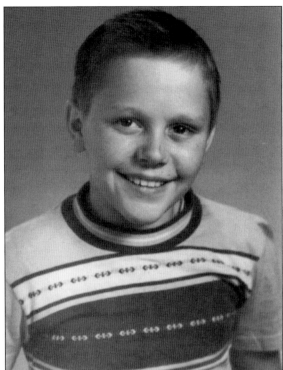

Most people in the village did not use the second floor of their homes perhaps out of fear of the "Booger Holes." Walls were constructed along the sides sealing off narrow eaves with a door-sized opening. Steve Burns remembers being told that the "Boogie Man" lived in this hole and was eager to carry off misbehaving children. Unfortunately, his bedroom was located on the second floor. (Courtesy of Steve Burns.)

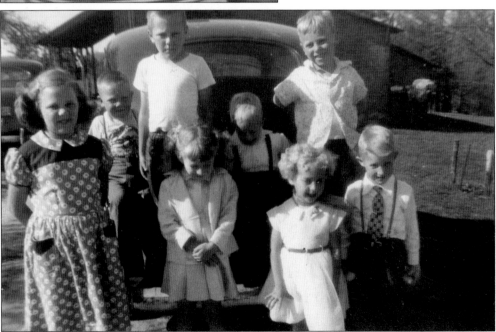

When cousins came to spend the night with Virgil and Edith Burns's children, ghost stories abounded. After the tales were told, the children would have to sleep next to the "Booger Hole." Needless to say, this resulted in many sleepless nights. Pictured are, from left to right, (first row) Brenda, Ann, Patsy, and Ray Burns; (second row) Paul Brittain and Steve, Mike, and Ernie Burns. (Courtesy of Steve Burns.)

Sherry Newton was five years old when her daddy, Melvin, left her home alone for a short while. Because she had seen her mother shave her legs, Sherry saw this as a perfect opportunity to shave her own. Unable to find a razor, she used her daddy's pocketknife instead. It was many years before she felt the need to shave her legs again. (Courtesy of Sherry Newton Wilson.)

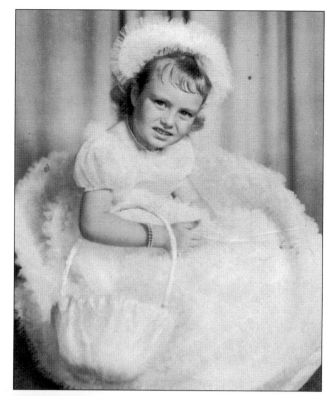

Boredom in the village sometimes led to dangerous practical jokes. Ex-lax was often slipped into food, and laughter ensued. Garvey Bean, right, remembers a hot summer day when someone gave ex-lax to a dog. The dog's owner retaliated by beating the offender with a coke bottle. (Courtesy of Garvey Bean.)

In the spring of 1948, Roger Smith (left) and Clayton Lowman (right) plan their own fishing trip. With fishing poles and a jar of worms, they are well on their way to providing dinner. In addition to cooter-hunting and pole-fishing, many Henry River families also relied on frog-gigging and jug-fishing to supply them with food. Jug-fishing, especially, often proved fruitful. Ray Burns tells a story of catching washtubs full of catfish with Rob Lindsey. The two then had to spend hours cleaning all the fish. It is unlikely that young Clayton and Roger had that problem on this warm, sunny day. (Courtesy of Brenda Lowman.)

Electricity caused a stir in the village when it arrived in the 1940s. Paul Pope, left, and Gary Lynn, right, remember being taken by Tony Lynn for show-and-tell of a new "Electric Ice Box" with a compressor on top. Paul says that when his family finally got their own refrigerator they almost wore the door out opening and closing it to look inside. (Courtesy of Paul Pope.)

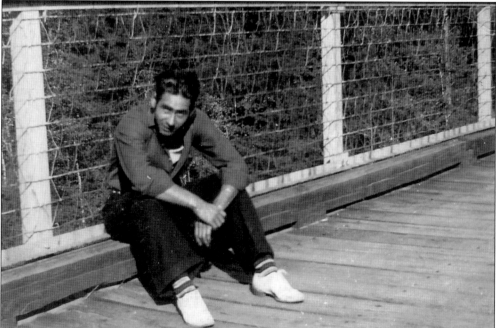

As a youngster, Charlie Smith swiped one of his mother's sheets to make a parachute. To test his invention, he caught a stray cat, tied it up, and threw the bundle over the side of the Henry River Bridge. It worked perfectly. The tomcat floated down and reached the shore unharmed. Hopefully, Charlie did not teach this trick to the little leaguers he coached later in life. (Courtesy of David Smith.)

In 1952, on his 12th birthday, David Smith's father, Charlie, took him upstairs in the Company Store to receive his birthday gift. David could not believe his eyes when he saw his first bicycle, a used Schwinn purchased from Norman Aderholdt. It was like new to him. About 60 years later, he is saving the bicycle for his grandson. (Courtesy of David Smith.)

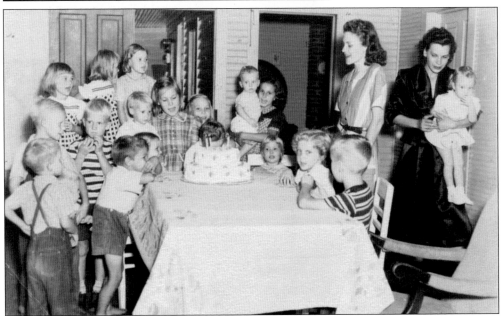

In early Henry River, birthday parties were few and far between. For most children, birthdays came and went like any other day. One year, Ricky Hames, whose head can be seen behind the candles, got lucky when his mother, Blanche, facing the cake, threw him a party in the big center room upstairs in the boardinghouse. All eyes are on the birthday cake as children wait to get their hands on a slice. (Courtesy of Evelyn Newton.)

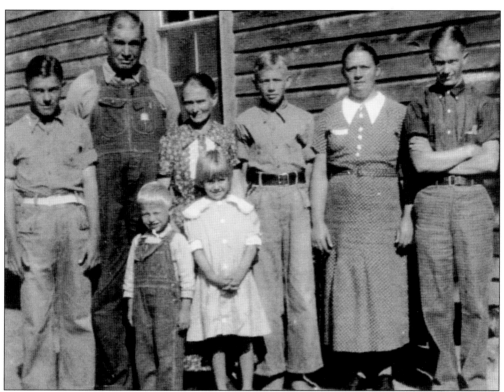

As a youngster, Ray Burns rode with his uncle Paul, third from right, in a mule-pulled wagon to plow gardens. One evening, Ray recalls a rabbit running out of the woods. With the help of the manual brake, the mule and wagon came to a quick halt. Paired with biscuits, gravy, fresh butter, and jelly prepared by Grandma Burns, Paul had found that night's supper. (Courtesy of Ray Burns.)

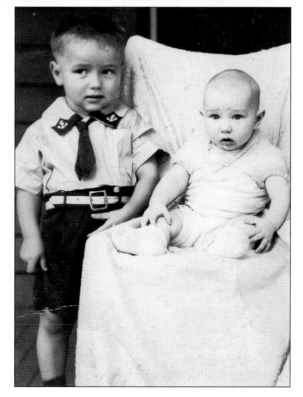

Kept in small glass bowls that contained water, tiny turtles were favorite pets for children in the 1930s. One suppertime, Katie Young Childers lost track of two-year-old Clarence, left, who she was babysitting while his parents Ed and Lucy Lane worked in the mill. When Clarence was finally found, he was sitting by the turtle bowl, dipping his biscuit into the water and eating it. (Courtesy of Clarence Lane.)

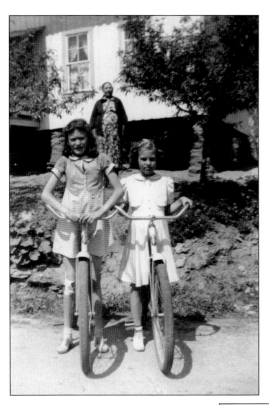

On warm days, there was nothing Maxine Newton Hefner, left, and Evelyn Lynn Newton, right, loved more than riding their bikes through the streets. Dovie Lail can be seen in the background, keeping an eye on the two girls. In Henry River, people believed in looking after one another; it truly took a village to raise the village. (Courtesy of Evelyn Newton.)

Carol Cline Willis lived at the top of the hill with her parents, Ed and Rose. One summer afternoon, she was playing the dangerous game of holding on to the side of a car with the window down while riding her bicycle. Letting loose of the car, her bicycle sped down the steep hill. Both Carol and the bicycle ended up in the river. (Courtesy of Verlene Hicks.)

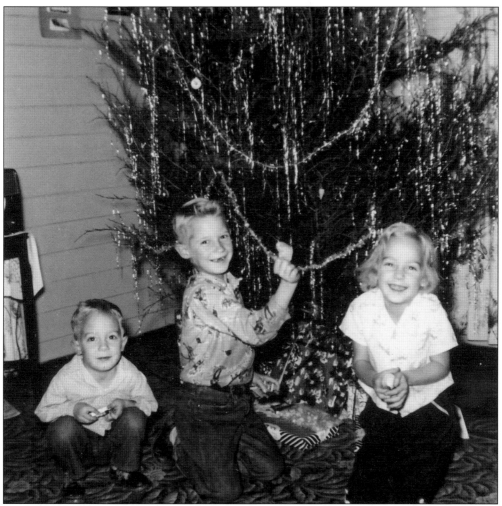

Especially during the Depression, there were occasions when the mill was forced to stop production for a period of time. Although, due to river power, the mill was usually at its production peak from November to late spring, one year it was forced to halt operations around Christmastime. Families were even shorter on money than usual. Since Sam Pope's grocery store was the only store that would extend credit to him, Leroy Burns's family's presents came from Sam's that year. Here, in a more prosperous year, Patsy Burns (right) shows off her new pet bird. (Courtesy of Ray Burns.)

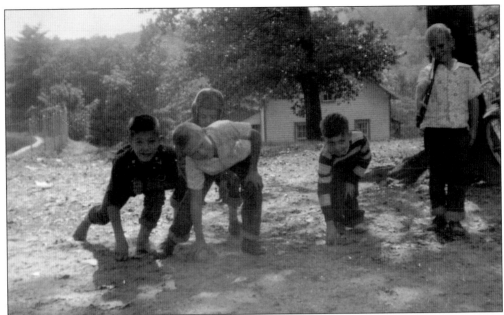

From left to right, Mickey Lynn, Elliott Holloway, Gary Lynn, Doug Reep, and Ricky Hames enjoy a football game in the field between the boardinghouse and the reservoir. Mickey was considered by many to be "one heck of a" football player. Even without the fancy lights and uniforms, the boys found a way to enjoy the game. (Courtesy of Mel Newton.)

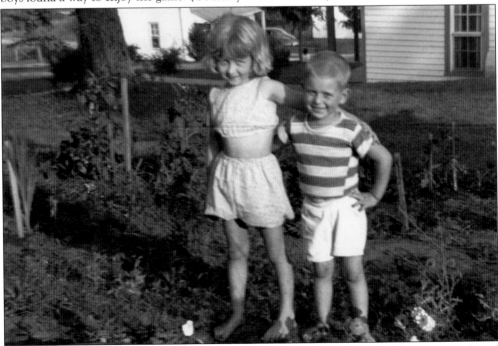

Of all the memories that Janie Bollinger Green, left, has of visiting her grandparents Frank and Lillie Bollinger, she loves them all except for the big goose that lived outside near the toilet. Known to terrorize children, the goose made her final mistake when she pinched Lillie and ended up on the dinner table. (Courtesy of Janie Green.)

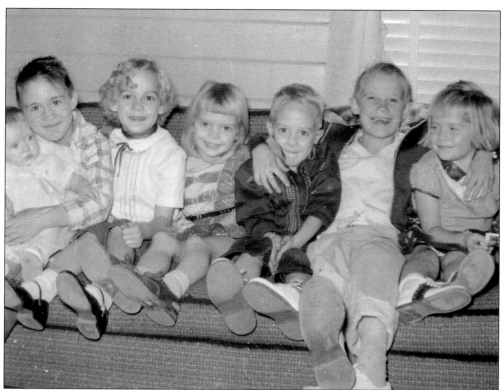

With no bathrooms or running water, villagers found alternatives. Washtubs were filled with water and then left all day in the sun to warm. The warmed tub was then carried into the house where children bathed one at a time. Depending on the number of children, by the time the last one got a bath, the water in the tub could be quite cold and dirty. Pictured are the Burns cousins, many who remember cold, dirty tubs! (Courtesy of Ray Burns.)

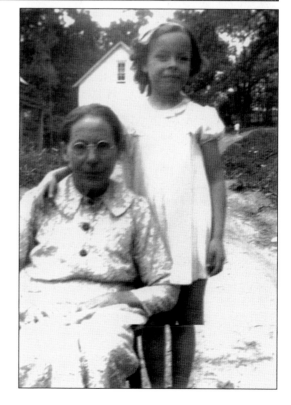

Sam Pope, whose mother, Alice, is pictured here, rigged up a shower in the back of his house where folks could bathe for a small fee. Visually disabled, Sam earned a solid living at his store and was known to be a kindhearted man. Ray Burns recalls how, when he was a boy delivering the *Hickory Daily Record*, Sam would tip him a dime. (Courtesy of Zero Crump.)

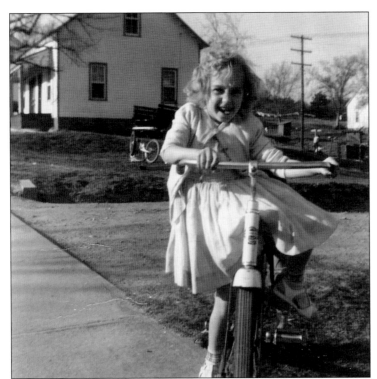

In 1956, Patsy Burns, dressed in frills because girls did not wear pants, learned to ride her bike. Patsy lived on the hill for a number of years and remembers carrying water for both her house and her mother, Margaret's. Patsy's sons Wayne and Scott were ashamed to be seen carrying water and would hide their buckets behind trees when they heard a car approaching. (Courtesy of Patsy Burns.)

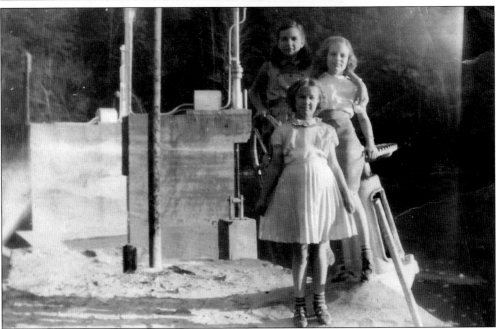

Polly Childers Abernathy (top), Evelyn Lynn Newton (center), and Beatrice Childers Brittain (bottom) pose on the wing wall of the dam. Most villagers on the hill had their photograph taken here multiple times. Henry River itself played an essential role in the life of the villagers, providing a place to swim, bathe, fish, cooter-hunt, frog-gig, be photographed, and baptized. (Courtesy of Evelyn Newton.)

In the winter of 1941, leaves scatter the Henry River grounds, and children bundle up in their Sunday best. Clockwise are, from left to right, Paul Burns, Charles Pope, Archie Hudson, Carol Cline, Ruby Young, Phyllis Burns, Scotty Sue Lynn, and Bernice Cline. The church often gave children take-home pamphlets with Bible tales. These pamphlets contained pictures and stories and were often treasured by the children. Back home, the children show off what they did in Sunday school. They will likely join their families for Sunday dinner and then head back to the church for more worship services. (Courtesy of Ruby Keller.)

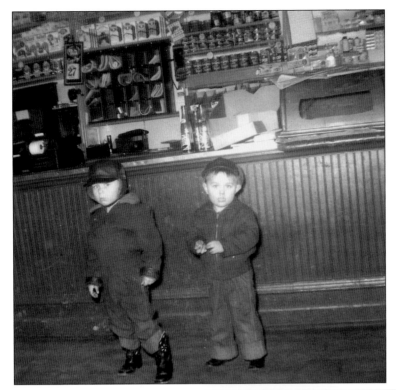

As a little boy, Sam Young was struck with appendicitis. His mother's sister Martha Young took him to the hospital and ensured that he received surgery. Sam and his wife, Betty, worked and lived in Henry River. Pictured are their sons Donnie (left) and Ricky on a visit to the Company Store. Behind the counter are the boxes used for residents' mail. (Courtesy of Ruby Keller.)

When the first television arrived on the hill, Paul Pope remembers that children rushed to the house to sit on the floor to see what a television was. At the time, there were only two stations. Children sat patiently, sometimes for hours, watching the test pattern until *Hopalong Cassidy* came on. As villagers were able to buy sets, they always had a floor full of children. (Courtesy of Paul Pope.)

Frances Cline Beckom, pictured, and Betty Cline loved to play house. When electricity came to Henry River and their parents bought a wringer washer, a washhouse was built in the backyard. That year, when it was time to take the Christmas tree down, the girls saved the tree by putting it in the washhouse, making paper decorations and reliving Christmas for months. (Courtesy of Paul Pope.)

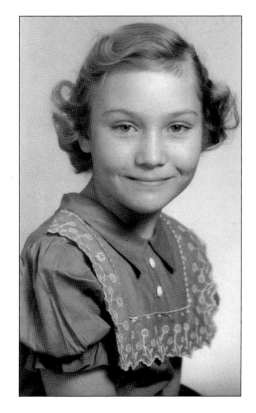

On the first day of school, Ray Pope's teacher asked him his name. When he replied that he was "Billy Ray Pope," the teacher said that his name *must* be short for William Raymond Pope. "Ask your mother tonight," she said, "and tell me your real name tomorrow." After Ray's mother, Ainer, spoke with the teacher the next day, the teacher never questioned another child's name. (Courtesy of Ray Burns.)

Snow days on the hill were always a favorite. Living between two hills, residents were assuredly snowed in. Snow was scooped up into pans for snow-cream that was sometimes frozen to be enjoyed throughout the year. With no real sleds, children made do with cardboard or old tires. Many snowmen were built, but at least one pictured here seems to have a human head. (Courtesy of Ray Burns.)

In the mid-1940s, a bus service was started in Hickory with four daily trips to Henry River. Because their parents worked the second shift, Mabel Cline, pictured, and Ruby Young often caught the 6:00 bus, took in a movie, and returned home by 9:30. Although Henry River Church preached that going to movies was a sin, the girls enjoyed many a delightful, sinful trip on the bus. (Courtesy of Ruby Keller.)

On Halloween, village children loved dressing up in old clothes and trick-or-treating with paper sacks. The first place everyone wanted to go was to the Miles Aderholdt house. Children then went back down the hill to knock on all 35 doors of the village. Residents were generous. At evening's end, the bags were full. Ray Burns (left) and Gary Lynn relax in the front yard. (Courtesy of Ray Burns.)

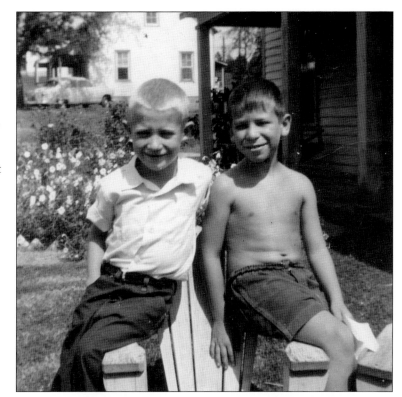

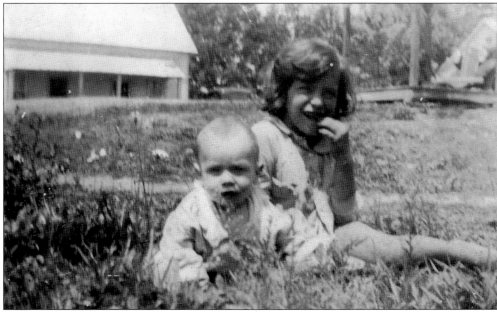

Verlene Hicks remembers being best friends with Scotty Sue Lynn, right. The two dreamed of going to Hollywood and once even attempted to write a romance novel, though they never got through the first chapter. One afternoon, riding double on a bicycle on their way home from ball practice, they wrecked. Verlene received medical care for a knee injury, and Scotty Sue sported a black eye. (Courtesy of Ray Burns.)

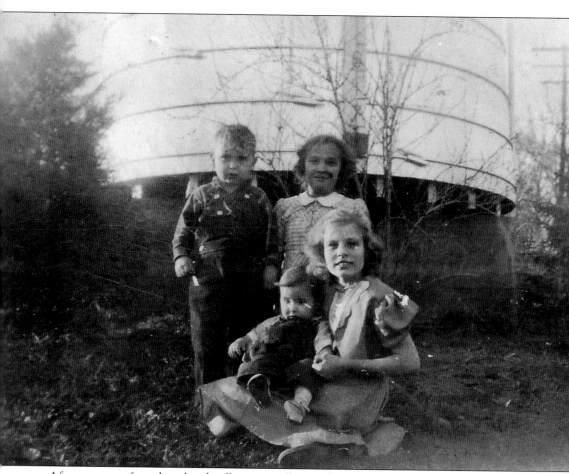

After a supper of cornbread and milk, young villagers often wandered down to the beautiful lawn that spread out below the water tower to talk and carry on and relax after a long day. Courting was usually reserved for out in front of the ball field. Here, on the freshly mowed grass near the path that ran up through the village, friendships were secured and dreams were shared. Savoring their time together before nightfall, the young people almost always made it home before dark. Wayne and Polly Childers stand behind Evelyn Newton who holds Beatrice Childers. (Courtesy of Mel Newton.)

Six

AN EERIE SILHOUETTE

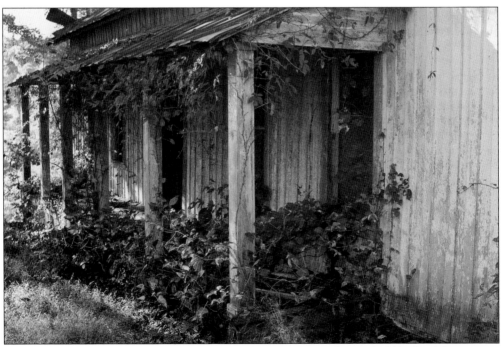

Today, a short detour off the Interstate 40 exit, the Henry River houses hold little of the vivacity that they once contained. In 1976, Wade Shepherd purchased the 76-acre site but abandoned his hopes to revitalize it after the mill itself burned down in 1977. Now, "No Trespassing" signs dot the village and little can be heard beyond the wind through the trees. (Courtesy of Diane Fields.)

Many who pass through the village speak of its haunting, lovely quality. In this photograph, taken by Diane Fields, the shadow of a large tree dwarfs a village home. This is not one of the pretty maple trees that Miles Aderholdt had planted along the Henry River road to make the village more appealing. Instead, it is a powerful, indigenous breed, ominous and looming. Shadows of another time—a time of washboards and quilts, of blackberry dumplings, and of two-finger fiddle players—abound in Henry River. Even the neglect of these homes fails to eclipse the shadows. (Courtesy of Diane Fields.)

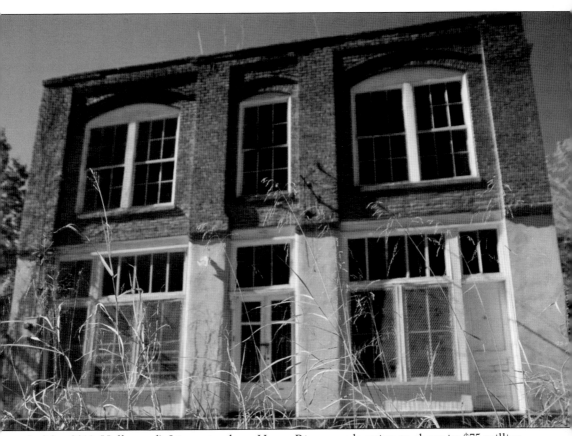

In May 2011, Hollywood's Lionsgate chose Henry River as a location to shoot its $75-million postapocalyptic film, *The Hunger Games*. Village streets bustled, and laundry hung from lines. Some believed that producers were disturbing old ghosts by stomping on broken-down porches; others were just grateful for a little attention. After the filming, the village returned to its tranquil state. Only those who knew the village like the back of their hand would notice the differences. Most visible from the main road, the words "pastries" and "cakes" were added to the front of the Company Store, which serves as a crucial setting for the movie's District 12. (Courtesy of Diane Fields.)

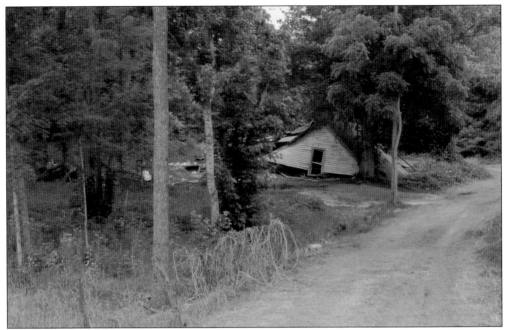

Located on the little dirt road that went down to Dog Trot, this was the house that was blown up in the making of *The Hunger Games*. A house that once held the lives and then contained the memories of villagers is now gone, sacrificed for a plot point. (Courtesy of Mel Newton.)

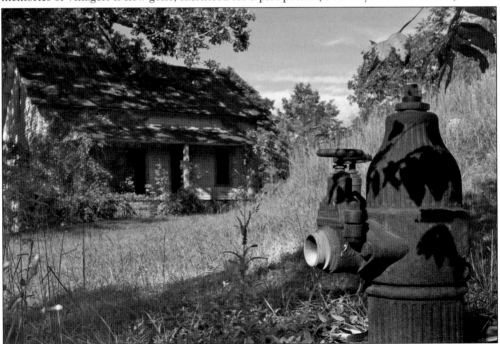

In the foreground is a community hydrant used to pull water from the reservoir to fight fires. Unfortunately, over the years, fire has proved to be the force that haunts Henry River most steadily. Besides the 1977 burning of the mill, 15 of the village houses no longer stand, the majority of which fell prey to flames. (Courtesy of Diane Fields.)

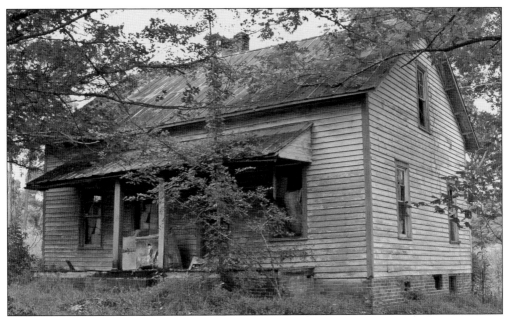

An unkempt lawn and a house packed with items no longer wanted, this was the predominant feel of most of the remaining village homes when Diane Fields captured this photograph in 2001. Recent efforts, however, have, at the very least, cleaned up the grounds. While Henry River still seems dangerously close to its end, it does not feel nearly as neglected as it did a decade ago. (Courtesy of Diane Fields.)

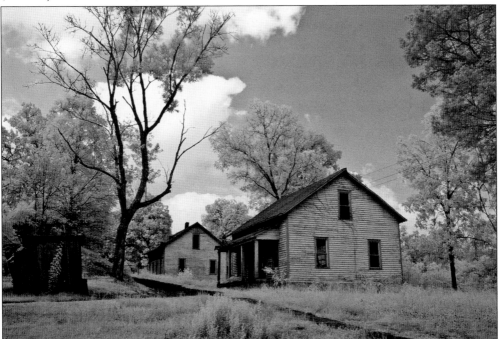

Tim Peeler, a local writer and poet, also finds inspiration from Henry River Mill Village. He writes, "The children floated / Like ghosts in the dusk / Catching fireflies / In chipped jelly jars / Till mommas called / From one bulb porches / Up and down the hill." (Courtesy of Diane Fields.)

Tim Peeler goes on to write of penny candy and moons crossing windows, of baseball diamonds and left-handed banjos. "Down the steps to the dam," he writes in one poem, "That look like they're carved / Straight from a granite ledge, / A father carries his toddler son / Toward the camera, / Huge hands draped around / The boy's chest, both of them / Wearing the slight smiles / Of contented humans who sense / That like on this bright day, / The sun will always be behind them." Diane Fields, through her lens, manipulates light and shadow to show the eerie presence of that which has been loved and worn and forgotten. Each offers a door into another time, and other artists—filmmakers, musicians, and painters—feed off the same inspiration. (Both, courtesy of Diane Fields.)

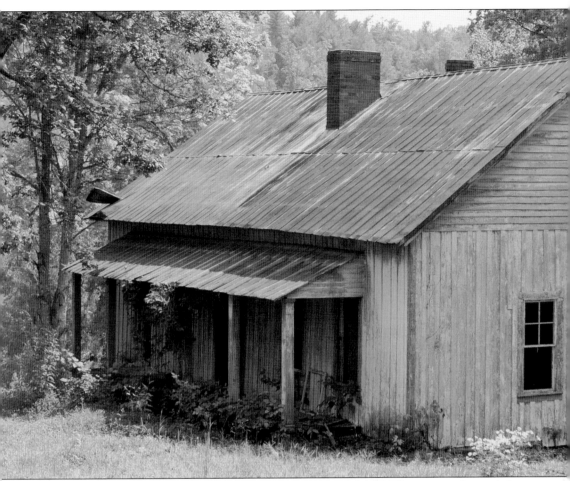

There is hope, however, that the preservation of Henry River Mill Village can go beyond the artistic world. While former villagers read the poems and carefully examine the photographs, and many more will surely stand in line at *The Hunger Games* movie hoping to catch a glimpse of the place they once called home, there are still more who believe that the town itself is worthy of preservation. (Courtesy of Diane Fields.)

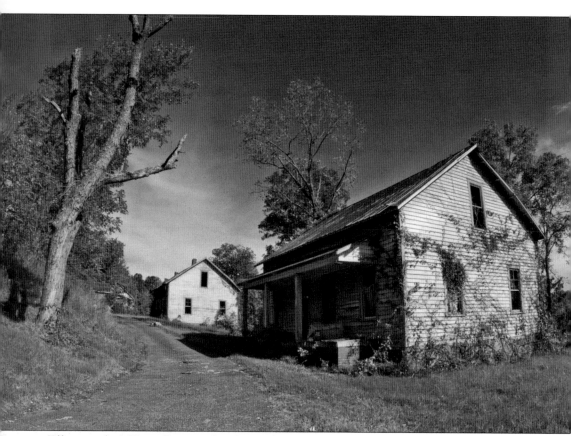

Efforts to place Henry River in the National Register of Historic Places have been thwarted, but with the recent development of the Henry River Preservation Committee under the umbrella of the Historic Burke Foundation, there is an abounding optimism that this important remnant of the industrial heritage of the United States will be salvaged. (Courtesy of Diane Fields.)

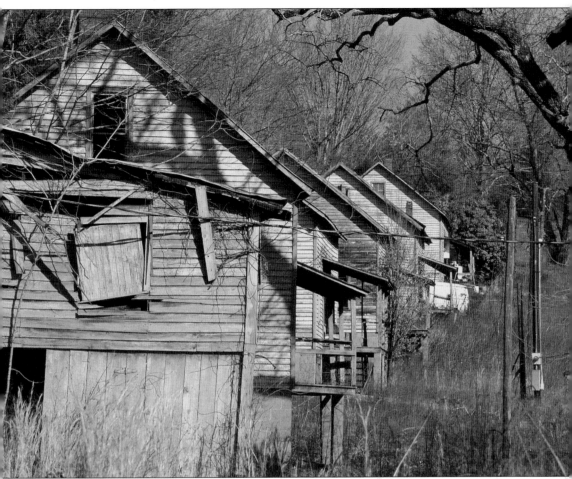

Over 100 years have passed since the founders first looked out at Henry River and saw within its moving current the potential it held. In those years, curtains have been hung and taken down; lives have been birthed and lost; hearts have been healed and broken and healed again. It does not take much to imagine sliding a coin across the counter for a dope from the Company Store or sitting on the front porch shaking salt onto a slice of Moon-and-Star watermelon. While the future of Henry River Mill Village may be unknown, the past is quite certain. It serves not only as a rich account of the North Carolina textile industry but also as a true testament to a community that flourished even in hardship. (Courtesy of Diane Fields.)

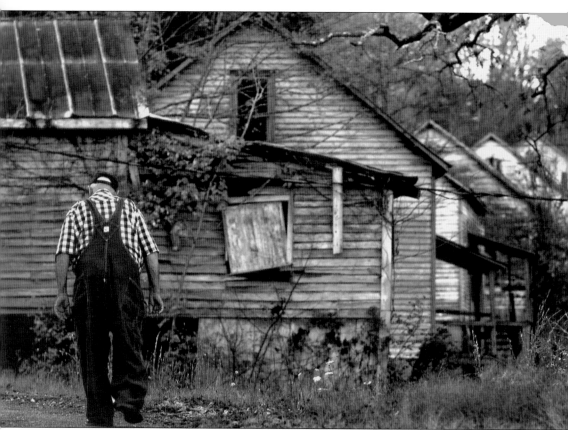

Bud Rudisill, who lived in the village for 82 of his 96 years, takes a final stroll through the streets of Henry River. Having raised his family in the little house on the sharp curve across from the store, Bud had a harder time than most trying to break away from the village. He was known for sitting on his porch and waving at passersby. Though he began his time at the mill making only eight and a third cents per hour, he was deeply fulfilled by his life in the village, fulfilled like so many others were, and—if preservation efforts succeed—so many more might be. (Courtesy of Jeff Willhelm.)

ABOUT THE ORGANIZATION

Operated under the umbrella of the Historic Burke Foundation, the Henry River Preservation Committee was founded to protect, enhance, and perpetuate our heritage so as to ensure the stability of Henry River Mill Village for present and future generations. To preserve this heritage, we seek to provide assistance in preserving architecturally significant properties and to focus attention on the community's history. These resources serve as visible reminders of the village's history. Preservation efforts also contribute to the economic development and vitality of Burke County, fostering a sense of civic pride and an appreciation of the industrial heritage of the state of North Carolina.

Discover Thousands of Local History Books Featuring Millions of Vintage Images

Arcadia Publishing, the leading local history publisher in the United States, is committed to making history accessible and meaningful through publishing books that celebrate and preserve the heritage of America's people and places.

Find more books like this at
www.arcadiapublishing.com

Search for your hometown history, your old stomping grounds, and even your favorite sports team.

Consistent with our mission to preserve history on a local level, this book was printed in South Carolina on American-made paper and manufactured entirely in the United States. Products carrying the accredited Forest Stewardship Council (FSC) label are printed on 100 percent FSC-certified paper.

MADE IN THE **USA**